"J. R. R. Tolkien wrote that what he called the 'story-germ,' the shape of a fictional narrative, grows from an author's experience in unpredictable ways. Tolkien was a deeply devout Christian who knew the Bible well. He insisted that he did not write in order to 'make a point,' and certainly not to express doctrine in allegorical dress. Yet Phil Ryken shows how profoundly Tolkien's imagination was shaped by Jesus Christ himself, revealing the rich theological insights we can receive from the great tales if we are attentive to them. This book is a treat, filled with surprises."

Tim Keller, pastor emeritus, Redeemer Presbyterian Churches of New York City

"In *The Messiah Comes to Middle-Earth*, Philip Ryken develops the notion that the presence of Christ in *The Lord of the Rings* follows a traditional tripartite form: prophet, priest, and king. Showing particularly how Tolkien develops this form through Gandalf, Frodo, and Aragorn, Ryken adeptly demonstrates that a knowledge of theology and Middle-earth mutually illuminate Tolkien's texts. The plausibility of the book's thesis is also enhanced through responses from other notable scholars, including Sandra Richter, Jennifer Powell McNutt, and William Struthers. This book is recommended for all who wish to enhance their understanding of the Christian theology that undergirds the entertaining fantasy of Tolkien's Middle-earth."

Gregory Maillet, professor of English, Crandall University

"Ryken draws from biblical studies, theology, and literature in a wonderfully integrated way: the result is abundant insight into Tolkien's Christian imagination. Erudite and still approachable, thoughtful and yet fun to read, far-ranging and deeply edifying. I am thrilled to recommend it."

Diana Pavlac Glyer, professor of English at Azusa Pacific University and author of *Bandersnatch* and *The Company They Keep*

"Phil Ryken not only draws upon a wealth of Tolkien scholarship, he adds some marvelous insights of his ⸱ ⸱⸱ ᵗʰᵉ spiritual and theological dynamics at play in Middle-earth ide us with much wisdom about the kir phetic, priestly, and kingly work of Jesu

Richard J. Mouw, president emeri⸱
Theological Seminary

"Phil Ryken brings his creative genius to bear on the beautiful work of Tolkien's *The Lord of the Rings*. Utilizing the threefold office of prophet, priest, and king, Dr. Ryken invites us to see in Gandalf (prophet), Frodo (priest), and Aragorn (king) image bearers like ourselves, who, in facing the haunting realities of their own existence, draw us into a deeper understanding and reflection on our own life with God. Utilizing his own mastery of English literature combined with his wide access to and conversation with the best of biblical scholarship, Phil has crafted a real treasure that will both nourish and inspire you. Enjoy the read."

Gayle D. Beebe, president, Westmont College

"Ryken effectively draws out Tolkien's subtle use of Christ's threefold office (prophet, priest, king) by filtering his argument not only through the best of Tolkien scholarship but through the Old Testament, the church fathers, the Reformers, and his own multifaceted role as president of a Christ-centered college."

Louis Markos, professor in English and scholar in residence, Houston Baptist University, author of *On the Shoulders of Hobbits*

HANSEN LECTURESHIP SERIES

The MESSIAH COMES TO MIDDLE EARTH

IMAGES *of* CHRIST'S
THREEFOLD OFFICE *in*
the LORD *of the* RINGS

PHILIP RYKEN

IVP Academic
An imprint of InterVarsity Press
Downers Grove, Illinois

InterVarsity Press
P.O. Box 1400, Downers Grove, IL 60515-1426
ivpress.com
email@ivpress.com

InterVarsity Press® is the book-publishing division of InterVarsity Christian Fellowship/USA®, a movement of students and faculty active on campus at hundreds of universities, colleges, and schools of nursing in the United States of America, and a member movement of the International Fellowship of Evangelical Students. For information about local and regional activities, visit intervarsity.org.

Cover design: David Fassett
Interior design: Daniel van Loon
Images: polished metal background: © GOLDsquirrel/iStockphoto

ISBN 978-0-8308-5372-4 (print)
ISBN 978-0-8308-8886-3 (digital)

Printed in the United States of America ♾

InterVarsity Press is committed to ecological stewardship and to the conservation of natural resources in all our operations. This book was printed using sustainably sourced paper.

Library of Congress Cataloging-in-Publication Data
A catalog record for this book is available from the Library of Congress.

P 25 24 23 22 21 20 19 18 17 16 15 14 13 12 11 10 9 8 7 6 5 4 3 2 1

Y 36 35 34 33 32 31 30 29 28 27 26 25 24 23 22 21 20 19 18 17

CONTENTS

Introduction *to the* Hansen
Lectureship Series

WALTER HANSEN

THE KEN AND JEAN HANSEN LECTURESHIP

I was motivated to set up a lectureship in honor of my parents, Ken and Jean Hansen, at the Wade Center primarily because they loved Marion E. Wade. My father began working for Mr. Wade in 1946, the year I was born. He launched my father and mentored him in his business career. Often when I look at the picture of Marion Wade in the Wade Center, I give thanks to God for his beneficial influence in my family and in my life.

After Darlene and I were married in December 1967, the middle of my senior year at Wheaton College, we invited Marion and Lil Wade for dinner in our apartment. I wanted Darlene to get to know the best storyteller I've ever heard.

When Marion Wade passed through death into the Lord's presence on November 28, 1973, his last words to my father were, "Remember Joshua, Ken." As Joshua was the one who followed Moses to lead God's people, my father was the one who followed Marion Wade to lead the ServiceMaster Company.

After members of Marion Wade's family and friends at Service-Master set up a memorial fund in honor of Marion Wade at Wheaton College, my parents initiated the renaming of Clyde

Kilby's collection of papers and books from the seven British authors—C. S. Lewis, J. R. R. Tolkien, Dorothy L. Sayers, George MacDonald, G. K. Chesterton, Charles Williams, and Owen Barfield—as the Marion E. Wade Collection.

I'm also motivated to name this lectureship after my parents because they loved the literature of these seven authors whose papers are now collected at the Wade Center.

While I was still in college, my father and mother took an evening course on Lewis and Tolkien with Dr. Kilby. The class was limited to nine students so that they could meet in Dr. Kilby's living room. Dr. Kilby's wife, Martha, served tea and cookies.

My parents were avid readers, collectors, and promoters of the books of the seven Wade authors, even hosting a book club in their living room led by Dr. Kilby. When they moved to Santa Barbara in 1977, they named their home Rivendell, after the beautiful house of the elf Lord Elrond, whose home served as a welcome haven to weary travelers as well as a cultural center for Middle-earth history and lore. Family and friends who stayed in their home know that their home fulfilled Tolkien's description of Rivendell:

> And so at last they all came to the Last Homely House, and found its doors flung wide. . . . [The] house was perfect whether you liked food, or sleep, or work, or story-telling, or singing, or just sitting and thinking best, or a pleasant mixture of them all. . . . Their clothes were mended as well as their bruises, their tempers and their hopes. . . . Their plans were improved with the best advice.[1]

Our family treasures many memories of our times at Rivendell, highlighted by storytelling. Our conversations often drew from

[1]J. R. R. Tolkien, *The Hobbit* (London: Unwin Hyman, 1987), 50-51.

images of the stories of Lewis, Tolkien, and the other authors. We had our own code language: "That was a terrible Bridge of Khazad-dûm experience." "That meeting felt like the Council of Elrond."

One cold February, Clyde and Martha Kilby escaped the deep freeze of Wheaton to thaw out and recover for two weeks at my parents' Rivendell home in Santa Barbara. As a thank-you note, Clyde Kilby dedicated his book *Images of Salvation in the Fiction of C. S. Lewis* to my parents. When my parents set up our family foundation in 1985, they named the foundation Rivendell Stewards' Trust.

In many ways, they lived in and they lived out the stories of the seven authors. It seems fitting and proper, therefore, to name this lectureship in honor of Ken and Jean Hansen.

ESCAPE FOR PRISONERS

The purpose of the Hansen Lectureship is to provide a way of escape for prisoners. J. R. R. Tolkien writes about the positive role of escape in literature:

> I have claimed that Escape is one of the main functions of fairy-stories, and since I do not disapprove of them, it is plain that I do not accept the tone of scorn or pity with which "Escape" is now so often used: a tone for which the uses of the word outside literary criticism give no warrant at all. In what the misusers of Escape are fond of calling Real Life, Escape is evidently as a rule very practical, and may even be heroic.[2]

Note that Tolkien is not talking about escap*ism* or an avoidance of reality, but rather the idea of escape as a means of providing a new

[2]J. R. R. Tolkien, "On Fairy-Stories," in *Tales from the Perilous Realm* (Boston: Houghton Mifflin, 2008), 375.

view of reality, the true transcendent reality that is often screened from our view in this fallen world. He adds:

> Evidently we are faced by a misuse of words, and also by a confusion of thought. Why should a man be scorned, if, finding himself in prison, he tries to get out and go home? Or if, when he cannot do so, he thinks and talks about other topics than jailers and prison-walls? The world outside has not become less real because the prisoner cannot see it. In using Escape in this [derogatory] way the [literary] critics have chosen the wrong word, and, what is more, they are confusing, not always by sincere error, the Escape of the Prisoner with the Flight of the Deserter.[3]

I am not proposing that these lectures give us a way to escape from our responsibilities or ignore the needs of the world around us, but rather that we explore the stories of the seven authors to escape from a distorted view of reality, from a sense of hopelessness, and to awaken us to the true hope of what God desires for us and promises to do for us.

C. S. Lewis offers a similar vision for the possibility that such literature could open our eyes to a new reality:

> We want to escape the illusions of perspective. . . . We want to see with other eyes, to imagine with other imaginations, to feel with other hearts, as well as with our own. . . .
>
> The man who is contented to be only himself, and therefore less a self, is in prison. My own eyes are not enough for me, I will see through those of others. . . .
>
> In reading great literature I become a thousand men yet remain myself. . . . Here as in worship, in love, in moral

[3]Ibid., 376.

action, and in knowing, I transcend myself; and am never more myself than when I do.[4]

The purpose of the Hansen Lectureship is to explore the great literature of the seven Wade authors so that we can escape from the prison of our self-centeredness and narrow, parochial perspective in order to see with other eyes, feel with other hearts, and be equipped for practical deeds in real life.

As a result, we will learn new ways to experience and extend the fulfillment of our Lord's mission: "to proclaim freedom for the prisoners and recovery of sight for the blind, to set the oppressed free" (Lk 4:18 NIV).

THE GOOD CATASTROPHE

One particular scene from Tolkien's *The Return of the King* captures well what I hope this lecture series will provide. This scene takes place just outside the Crack of Doom after the One Ring of Power was destroyed:

> "I am glad that you are here with me," said Frodo. "Here at the end of all things, Sam."
>
> "Yes, I am with you, Master," said Sam, laying Frodo's wounded hand gently to his breast. "And you're with me. And the journey's finished. But after coming all that way I don't want to give up yet. It's not like me, somehow, if you understand."
>
> "Maybe not, Sam," said Frodo; "but it's like things are in the world. Hopes fail. An end comes. We have only a little time to wait now. We are lost in ruin and downfall, and there is no escape."[5]

[4]C. S. Lewis, *An Experiment in Criticism* (Cambridge: Cambridge University Press, 1965), 137, 140-41.

[5]J. R. R. Tolkien, *The Return of the King* (Boston: Houghton Mifflin, 1967), 228.

But then there is a sudden turn in the story. We see in the next scene that ruin and downfall, the end of all things, the worst catastrophe, is unexpectedly reversed, and it becomes a good catastrophe, a "eucatastrophe." Our sorrow turns to joy as Frodo and Sam are lifted on eagles' wings and borne to safety and recovery.

Tolkien coined the word *eucatastrophe*—the good catastrophe—to express the reality of "a sudden and miraculous grace." It gives the reader "a catch of breath, a beat and lifting of the heart, and a piercing glimpse of joy and heart's desire."[6] The gospel, Tolkien says, "is the greatest and most complete conceivable eucatastrophe. But this story has entered History and the primary world.... Art has been verified.... Legend and History have met and fused."[7]

I have a book from my father's library by Clyde Kilby, *Tolkien & "The Silmarillion,"* signed "To Jean and Ken with love, Clyde Kilby." Beneath Dr. Kilby's signature my father wrote this note, dated January 1, 1991: "I must have read earlier but this reading was a special one for me. How I would enjoy rereading with my Jean." This type of reading nourished and strengthened my father during dark days of loneliness after my mother died in 1989. In his typical fashion, my father underlined sentences while he was reading, including these where Kilby quotes from Tolkien:

> The Gospels resemble fairy-stories in their far-flung intimations of an unearthly Joy. "The Birth of Christ is the eucatastrophe of Man's history. The Resurrection is the eucatastrophe of the story of the Incarnation. This story begins and ends in joy." ... The "Great Eucatastrophe" is the final redemption of man as declared in the Scriptures.[8]

[6]Tolkien, "On Fairy-Stories," 385-86.
[7]Ibid., 388-89.
[8]Clyde S. Kilby, *Tolkien & "The Silmarillion"* (Wheaton, IL: Harold Shaw, 1976), 54-55.

During the final months of my father's life in 1994, he filled his heart and mind with the gospel stories and the stories of the seven authors represented here in the Wade Center. He was well prepared by these stories of eucatastrophe to pass through a terribly painful death with courage into the presence of the Lord.

It is my prayer that the Hansen Lectures by Wheaton College faculty on these seven authors will give the hope and joy of the gospel, "the most complete conceivable eucatastrophe" to all who have reached the end of themselves and see no way of escape.

The lectures by Philip Ryken in this volume point to the way of escape from destructive powers by focusing on images of the Messiah in Tolkien's story. Dr. Ryken serves as a wise guide through Middle-earth and *The Lord of the Rings* so that we see with deeper understanding how the Messiah came to our earth as our prophet, priest, and king to be our way of deliverance from evil powers.

Drawing from familiar images in Tolkien's story, I offer this benediction on all who will hear and read the Hansen Lectures:

May you find healing at Rivendell.

May you receive gifts for your journey at Lothlórien.

May you escape the darkness of Mordor on eagles' wings.

May you always love and be loved in the Fellowship of the King.

Abbreviations

FR J. R. R. Tolkien, *The Fellowship of the Ring*, part one of *The Lord of the Rings* (Boston: Houghton Mifflin, 1993).

RK J. R. R. Tolkien, *The Return of the King*, part three of *The Lord of the Rings* (Boston: Houghton Mifflin, 1993).

Sil J. R. R. Tolkien, *The Silmarillion*, 2nd ed., ed. Christopher Tolkien (Boston: Houghton Mifflin, 2001).

TT J. R. R. Tolkien, *The Two Towers*, part two of *The Lord of the Rings* (Boston: Houghton Mifflin, 1993).

1

The PROPHETIC MINISTRY
of GANDALF *the* GREY

As the Nine Walkers seek passage through the Misty Mountains, by way of Moria, they face terrifying evil. Dark spirits have been awakened from the deep, and their drum beats roll through the mine, echoing in the caverns and throbbing fear into the heart of the Fellowship of the Ring: *doom, doom*. A grim company of orcs attack, accompanied by massive trolls. For a moment, the Walkers narrowly escape, but soon their enemies are after them again: *doom-boom, doom-boom!*

As they run for their lives, the leader of their company—Gandalf the Grey—suddenly faces an enemy he has never met before. It is "like a great shadow, in the middle of which was a dark form, of man shape maybe, yet greater; and a power and terror seemed to be in it and to go before it. . . . In its right hand was a blade like a stabbing tongue of fire; in its left it held a whip of many thongs."[1] The fell creature is a Balrog—one of the last fiery demons who rebelled against Ilúvatar, the One God.[2]

[1]*FR*, 321.
[2]Robert Foster, *The Complete Guide to Middle-Earth* (New York: Random House, 2001), 39-40, 267-68.

As the Fellowship comes to the final bridge out of the mountains—the Bridge of Khazad-dûm—Gandalf seeks to hold the narrow passage long enough for his friends to escape. "You cannot pass," the wizard says. "Go back to the Shadow! You cannot pass." For a moment, the Balrog seems to wither. But then he draws himself up to his full height, leaps on the bridge, and strikes with deadly force:

> At that moment Gandalf lifted his staff, and crying aloud he smote the bridge before him. The staff broke asunder and fell from his hand. A blinding sheet of white flame sprang up. The bridge cracked. Right at the Balrog's feet it broke, and the stone upon which it stood crashed into the gulf, while the rest remained, poised, quivering like a tongue of rock thrust out into emptiness.
>
> With a terrible cry the Balrog fell forward, and its shadow plunged down and vanished. But even as it fell it swung its whip, and the thongs lashed and curled about the wizard's knees, dragging him to the brink. He staggered and fell, grasped vainly at the stone, and slid into the abyss. "Fly, you fools!" he cried, and was gone.[3]

It is easy to recognize Gandalf's heroic stand against the Balrog as an act of Christlike love. "Greater love has no one than this, that someone lay down his life for his friends," Jesus said (Jn 15:13). And this is precisely what Gandalf does: he sacrifices his life so that his friends may escape the dark power of evil. What I wish to argue is that Gandalf is Christlike in a particular way—that his work as a wizard is analogous to the ministry of the biblical prophets and thus illuminates both the office of Christ as prophet

[3] *FR*, 322.

and the prophetic calling of every Christian. In the unforgettable character of Gandalf the Grey, J. R. R. Tolkien has portrayed the archetypal prophet.[4]

But this is only one-third of the argument that I wish to make in these inaugural Hansen Lectures.[5] There are really three main Christ figures in *The Lord of the Rings*, and each one echoes a different aspect of the work of Christ—what theologians call his "threefold office" as prophet, priest, and king.

At the conclusion of his excellent book *The Philosophy of Tolkien*, Peter Kreeft astutely observes, "There is no one complete, concrete, visible Christ figure in *The Lord of the Rings*, like Aslan in Narnia. But Christ is really, though invisibly, present in the whole of *The Lord of the Rings*."[6] Perhaps this pervasive Christology helps to explain the unique power of Tolkien's epic fantasy, which some regard as the greatest fictional work of the twentieth century. The character of Christ is not a single thread in the story but is deeply woven into the entire narrative fabric. Indeed, is it possible for us to think of a book that more richly incarnates the themes of the gospel?

As Kreeft continues, he tells us more specifically where to look for the real but invisible presence of Christ:

He is more clearly present in Gandalf, Frodo, and Aragorn, the three Christ figures. First of all, all three undergo different

[4]Patrick Grant, "Tolkien: Archetype and Word," *Cross Currents*, Winter 1973, www.cross currents.org/tolkien.htm.

[5]I am deeply grateful to Walter and Darlene Hansen for their generous spirit and kingdom-minded vision in establishing the Ken and Jean Hansen Lectureship for the Marion E. Wade Center. Over many decades, both Wheaton College and the Ryken family have benefited greatly from the friendship of the Hansen family. I also wish to express my gratitude to Marjorie Mead, Lynn Wartsbaugh, and especially Laura Schmidt for their invaluable assistance in preparing the lectures on which this book is based.

[6]Peter J. Kreeft, *The Philosophy of Tolkien: The Worldview Behind "The Lord of the Rings"* (San Francisco: Ignatius, 2005), 222.

forms of death and resurrection. Second, all three are saviors: through their self-sacrifice they help save all of Middle-earth from the demonic sway of Sauron. Third, they exemplify the Old Testament threefold Messianic symbolism of prophet (Gandalf), priest (Frodo), and king (Aragorn).[7]

I wish to explore these connections more deeply by surveying the history of Christian thought on the threefold office of Christ and by considering how reading Tolkien can help us live out the prophetical, sacerdotal, and regal dimensions of our own calling as Christians. My approach will be literary, theological, and practical as I consider first "The Prophetic Ministry of Gandalf the Grey" and then "Frodo, Sam, and the Priesthood of All Believers," concluding with "The Coronation of Aragorn Son of Arathorn."

CHRIST'S THREEFOLD OFFICE IN THE CHURCH FATHERS

We begin by tracing some historical-theological background from the early church.[8] Apparently, the first theologian to describe the work of Christ in terms of his prophetic, priestly, and kingly ministry was Eusebius, the early fourth-century bishop of Caesarea.

Eusebius began his famous *Ecclesiastical History* by defining the term *Christ*, which, he noted, went all the way back to Moses and his anointing of Aaron as the high priest in Israel. The *Messiah*—or the *Christ*, to use the later Greek term—literally means "the anointed one." The majority of occurrences of this term in the Hebrew Bible refer to anointing the shepherd-king of Israel with holy oil (e.g.,

[7]Ibid., 222-23.

[8]For an excellent historical-theological summary, see the chapter "The Threefold Office in Retrospect" in Geoffrey Wainwright's *For Our Salvation: Two Approaches to the Work of Christ* (Grand Rapids: Eerdmans, 1997), 99-120.

1 Sam 10:1; Ps 89:20).[9] Eusebius also found the term in Psalm 2, a messianic song for the Son of David. On the basis of these and other scriptures, the venerable historian concluded that the work of Christ as the anointed one pertains to more than one Old Testament calling:

> Thus, it was not only those honoured with the high priesthood, anointed with prepared oil for the symbol's sake, who were distinguished among the Hebrews with the name of Christ, but the kings too; for they, at the bidding of God, received the chrism from prophets and were thus made Christs in image, in that they, too, bore in themselves the patterns of the kingly, sovereign authority of the one true Christ, the divine Word who reigns over all. Again, some of the prophets themselves by chrism became Christs in pattern, as the records show, so that they all stand in relation to the true Christ, the divine and heavenly Word who is the sole High Priest of the universe, the sole King of all creation, and of the prophets the sole Archprophet of the Father.[10]

The Old Testament priests, kings, and prophets were images or patterns, but there is only one true Christ, for whom Eusebius offered high praise:

> He did not receive the symbols and patterns of the high priesthood from anyone; He did not trace his physical descent from the acknowledged priests; He was not promoted by the soldiers' weapons to a kingdom; He did not become a prophet in the same way as those of old; He did not receive from the Jews any rank or pre-eminence whatever. Yet with

[9]See J. J. M. Roberts, "The Old Testament's Contributions to Messianic Expectations," in *The Messiah: Developments in Earliest Judaism and Christianity*, ed. James H. Charlesworth, The First Princeton Symposium on Judaism and Christian Origins (Minneapolis: Fortress, 1992), 39-51.

[10]Eusebius, *The History of the Church from Christ to Constantine*, trans. G. A. Williamson (New York: Penguin, 1965), 1.3 (42-43).

all these, not indeed in symbols but in very truth, He had been adorned by the Father. . . . He is more entitled than any of them to be called Christ . . . being Himself the one true Christ of God.[11]

Among the church fathers who followed Eusebius, the threefold office of Christ—or *munus triplex*—received little more than occasional mention. We do find the golden-tongued preacher John Chrysostom telling his congregation in Constantinople that "in old times, these three sorts were anointed": prophets and priests and kings.[12] We also find Peter Chrysologus, the fifth-century bishop of Ravenna, saying in one of his sermons that Jesus "was called Christ by anointing, because the unction, which in former times had been given to kings, prophets, and priests as a type, was now poured out as the fullness of the divine Spirit into this one person, the King of kings, Priest of priests, Prophet of prophets."[13]

CHRIST'S THREEFOLD OFFICE
IN SACRED SCRIPTURE

We will have to wait until the Protestant Reformation in Europe—which we will consider in the next chapter—to see how this three-dimensional schema gets developed in Christian doctrine. In the meantime, we should recognize that in commenting on Christ's threefold anointing, Eusebius, Chrysostom, and other patristic scholars were tapping into a rich vein of biblical truth.

[11]Ibid., 1.3 (43).

[12]John Chrysostom, *Homilies on the Epistles of Paul to the Corinthians*, Nicene and Post-Nicene Fathers, First Series, trans. Talbot W. Chambers, ed. Philip Schaff (1889; repr., Peabody, MA: Hendrickson, 1995), 12:290-93.

[13]Peter Chrysologus, *Sermo* 59 (Migne, *Patrologia Latina* 52.363), quoted in Wainwright, *For Our Salvation*, 111.

There are three primary forms of leadership in Old Testament Israel: prophet, priest, and king. To observe how these leaders operate and interact is to understand in many ways God's purposes for his people.

We can illustrate this from prophetic ministry. From Moses to Malachi, the prophets performed miraculous signs and gave God's Word to God's people, boldly speaking truth to power in the contemporary situation and perceptively foretelling the future.[14] This answered the people's need for guidance and deliverance.

Each of the Old Testament prophets received a divine call to sacred ministry. Think of Moses at the burning bush (Ex 3:1-10) or Isaiah in the temple, where he saw the holy Lord lifted high on his lofty throne (Is 6:1-8). The biblical prophets were not self-appointed; they were sent by God. On occasion—and here Elisha is the notable exemplar (1 Kings 19:16)—they were anointed for their holy office with sacred oil.

The biblical prophets fulfilled their calling to communicate God's Word, yet they were not without their flaws. Moses struck the rock in sinful anger (Num 20:2-13). Elijah ran away from his calling, threw himself down under a tree, and told God that he had had enough (1 Kings 19:1-10). Jeremiah cursed the day that he was born (Jer 20:14-18). As they considered the failings of these and other prophets, careful students of the ancient Scriptures looked in hope for God to fulfill his promise and raise up a prophet like Moses—one who would have God's very words in his mouth (Deut 18:15).

Enter Jesus, the Christ. In his singular person, Jesus fulfilled the promise of the prophetic office and indeed of all three offices, as

[14]For a clear and persuasive argument that all three offices are logocentric—united in their focus on reading and hearing the Word of God—see Uche Anizor, *Kings and Priests: Scripture's Theological Account of Its Readers* (Eugene, OR: Pickwick, 2014).

various theologians have noted. Here is how the Anglican bishop John Henry Newman summarizes the ways in which our Savior fulfilled his threefold office, from a notable Easter sermon he preached in 1840:

> Christ exercised His prophetical office in teaching, and in foretelling the future;—in His sermon on the Mount, in His parables, in His prophecy of the destruction of Jerusalem. He performed the priest's service when He died on the Cross, as a sacrifice; and when He consecrated the bread and the cup to be a feast upon that sacrifice; and now that He intercedes for us at the right hand of God. And He showed Himself as a conqueror, and a king, in rising from the dead, in ascending into heaven, in sending down the Spirit of grace, in converting the nations, and in forming his Church to receive and to rule them.[15]

For Karl Barth, who uses the threefold office of Christ as the structure for his soteriology, Jesus Christ is "the God-man who is instituted by God Himself, and who in the midst of world-history exists in His name, with His authority and in fulfillment of His will, suffering as High-priest, ruling as King and revealing Himself as Prophet."[16] Richard Mouw says, "We might put the case this way. In ancient Israel's social economy, God saw fit to develop three separate offices—prophet, priest, and king—along distinct and distinguishable lines. The roles and functions were separated for developmental preparatory purposes. But with the coming of Christ the offices are now gathered into an integral unity within

[15]John Henry Newman, "The Three Offices of Christ," in *Sermons, Bearing on Subjects of the Day* (London: Gilbert and Rivington, 1843), 60-61.

[16]Karl Barth, *Church Dogmatics* IV/3.1, ed. G. W. Bromiley and T. F. Torrance (Edinburgh: T&T Clark, 1961), 66.

one person."[17] And according to pastor and author Tim Keller, the promised Christ fulfills "all the powers and functions of ministry."[18]

To know our Savior in all his offices is to know him in a more complete way. So consider Christ in his prophetic office. At the outset of his public ministry, Jesus was set apart as a prophet—not by a mere anointing with oil but with the baptism of the Holy Spirit (Mt 3:16). On the basis of this divine chrism, Jesus read Isaiah's promise of the Messiah-prophet ("The Spirit of the Lord is upon me, because he has anointed me to proclaim good news to the poor"), sat down with prophetic authority, and announced, "Today this Scripture has been fulfilled in your hearing" (Lk 4:18-21; cf. Ps 105:15; Is 61:1).

In his own name and person, Jesus proceeded to preach the coming of God's kingdom (e.g., Mk 1:14-15) and to teach as no one had ever taught before—with personal divine authority. He claimed the unique ability and rightful commission to speak on his Father's behalf (Jn 8:26-29; 12:49). Although opinions about his identity varied (see Mt 16:13-14; Jn 7:40-43), there was no doubt as to his prophetic calling. Jesus performed miraculous signs, clarified the true meaning of the law, rebuked false teaching, and made many predictions about his own death and resurrection (e.g., Lk 9:22) as well as the final judgment and the end of the world (e.g., Mt 24). In response, the crowds said, "This is the prophet Jesus" (Mt 21:11; cf. Jn 1:45), and "This is indeed the Prophet who is to come into the world!" (Jn 6:14; cf. Lk 7:16; 24:19).

When the time came for him to die, Jesus exercised his prophetic office by teaching the Word of God. He used his "seven last

[17]Richard Mouw, "Leadership and the Three-Fold Office of Christ," in *Traditions in Leadership: How Faith Traditions Shape the Way We Lead*, ed. Eric O. Jacobsen (Pasadena, CA: The De Pree Leadership Center, 2006), 121.

[18]Timothy J. Keller, *Center Church: Doing Balanced, Gospel-Centered Ministry in Your City* (Grand Rapids: Zondervan, 2012), 344.

words" to remind us of the promises of God and to prophesy an entrance to paradise for the penitent thief who died on the cross next to him (Lk 23:43). Nor was death the end of his ministry as prophet. As soon as he was raised from the dead, Jesus resumed preaching the kingdom of God, teaching his disciples the implications of the cross and the empty tomb (Lk 24:44-49; Acts 1:1-3). This prophetic ministry of the gospel was not merely for the forty days leading up to the ascension but would also continue as the Holy Spirit guided the disciples into all truth (Jn 14:26; 16:13). Right up to the present moment, Jesus the anointed prophet remains "the faithful and true witness" (Rev 3:14).

GANDALF AS PROPHET

With this biblical and christological background in mind, we are ready to consider some of the ways in which Gandalf's coming to Middle-earth illuminates the ministry of anyone who is called to be a prophet.

To be sure, Gandalf is a wizard—Gandalf the Grey—whom Tolkien characterized as an "incarnate angel."[19] It is also true that on certain occasions Tolkien describes Gandalf as bearing kingly dignity. When he sits at the Council of Elrond, for example, and appears shorter in stature than the elves sitting beside him, nevertheless "his long white hair, his sweeping silver beard, and his broad shoulders, made him look like some wise king of ancient legend."[20]

But Gandalf's long white hair and sweeping silver beard equally call to mind the venerable mien of some biblical prophet. The

[19]J. R. R. Tolkien, *The Letters of J.R.R. Tolkien*, ed. Humphrey Carpenter (Boston: Houghton Mifflin, 2000), 202 (no. 156).

[20]*FR*, 220. See also *FR*, 291 ("he rose up, a great menacing shape like the monument of some ancient king of stone set upon a hill").

wizard also carries a staff in his right hand—a staff that features prominently in Frodo's lament after Gandalf meets his doom in the mines of Moria:

A lord of wisdom throned he sat,
swift in anger, quick to laugh;
an old man in a battered hat
who leaned upon a thorny staff.

He stood upon the bridge alone
and Fire and Shadow both defied;
his staff was broken on the stone,
in Khazad-dûm his wisdom died.[21]

Readers and moviegoers alike will remember Gandalf's stubborn reluctance to part with his old man's walking stick in the hall of Théoden.[22] This was with good reason, for like the prophet Moses (see Ex 4:17; 7:9-10; 14:16; etc.) and the prophet Elisha (2 Kings 4:29-31), Gandalf used his staff to perform miraculous signs and wonders. "Many wonderful things he did among us," said Faramir, the brave Captain of Gondor.[23]

Back in the Shire, Gandalf used his extraordinary power primarily for amusement. His fame among the hobbits there "was due mainly to his skill with fires, smokes, and lights."[24] But when trouble came, the old wizard could do a lot more than set off a few fireworks. After Frodo safely crossed into Rivendell at the Ford of Bruinen, where mighty waters miraculously swept away the horses of the Black Riders, Gandalf modestly admitted that he had "added a few touches" of his own: waves that "took the form of great

[21]*FR*, 351.
[22]*TT*, 500.
[23]*TT*, 655.
[24]*FR*, 25.

white horses with shining white riders" and "many rolling and grinding boulders."[25]

Gandalf used his miraculous powers in times of grave danger— when the company was attacked by wolves, for example[26]—or when the wizard bravely rode out of Minas Tirith to fend off the winged Nazgûl long enough for Faramir and his men to reach the safety of the city gates. When Pippin saw the Black Riders, he shouted, "Ah! I cannot stand it! Gandalf! Gandalf save us!" But when he saw the wizard ride out to meet the pressing danger, he shouted even more wildly: "Gandalf! Gandalf! He always turns up when things are darkest. Go on! Go on, White Rider! Gandalf! Gandalf!"[27]

Yet for all his miraculous powers, the wizard's prophetic in-fluence lay chiefly in the domain of wisdom. Gandalf shaped the affairs of Middle-earth by the power of his words. Indeed, this was his true calling. According to *The Silmarillion*—the legendary writings that provide the deep background for *The Lord of the Rings*—Gandalf and the other wizards were "mes-sengers sent by the Lords of the West to contest the power of Sauron."[28] The word *messenger* indicates that the wizards did not confront evil through military strength, but with the power of truth.

Although Frodo and his friends had other helpers, they de-pended mainly on Gandalf the Grey, the "chief counsellor and guide of those who work for the overthrow of Sauron,"[29] whom

[25] *FR*, 218.

[26] *FR*, 291.

[27] *RK*, 791.

[28] *Sil*, 299.

[29] Barry Gordon, "Kingship, Priesthood, and Prophecy in *The Lord of the Rings*" (unpublished paper, ca. 1967, University of Newcastle, Australia), 6, https://downloads.newcastle.edu.au /library/cultural%20collections/pdf/Kingship_priesthood_prophecy_in_the_LOTR.pdf.

Thorin Oakenshield introduced as "our friend and counselor, the ingenius wizard Gandalf."[30] Frodo did not set out from the Shire until Gandalf counseled him to do so. For until then, we are told, the wizard "had not at that time appeared or sent any message for several years."[31] Like Israel between the Testaments, the Shire was waiting for a prophetic word.

When Gandalf finally does speak, he advises Frodo as to which course he should take, thus setting in motion the events that would save Middle-earth. Frodo should travel "towards danger; but not too rashly, nor too straight."[32] Once the Fellowship of the Ring is formed, Gandalf serves as the guide, and his wisdom has the leading voice. Indeed, this is the reason the wizard gives for joining Frodo's quest. "I do not know if I can do anything to help you," he tells the brave hobbit, "but I will whisper in your ears. Someone said that intelligence would be needed in the party. He was right. I think I shall come with you."[33]

When the company falters at the doors of Moria, it is Gandalf who leads them into the deep mines and guides them through its dark and deadly paths. At a moment of doubt, when they seem to have lost their way, Aragorn says to the others: "Do not be afraid! Do not be afraid! I have been with him on many a journey, if never on one so dark; and there are tales of Rivendell of greater deeds of his than any that I have seen. He will not go astray—if there is any path to find. He has led us in here against our fears, but he will lead us out again, at whatever cost to himself."[34] And despite the cost,

See also Charles W. Nelson, "From Gollum to Gandalf: The Guide Figures in J. R. R. Tolkien's *Lord of the Rings,*" *Journal of the Fantastic in the Arts* 13, no. 1 (2002): 47-61.

[30]J. R. R. Tolkien, *The Hobbit, or There and Back Again* (Boston: Houghton Mifflin, 1995), 17.

[31]*FR*, 42.

[32]*FR*, 65.

[33]*FR*, 266; cf. 66.

[34]*FR*, 303.

Gandalf does lead them out again. His final instructions are just the words they need to make it out alive: "Fly, you fools!"[35]

Once Gandalf is dragged into the abyss, it is his wise guidance that Frodo and his fellow travelers miss most of all. In the long months that follow—as they lament his loss—they often wonder what course he would choose, what counsel he would give. "I cannot advise you," Aragorn says to Frodo at the feet of Amon Hen, when the Fellowship tries desperately to decide where to go next. "I am not Gandalf, and though I have tried to bear his part, I do not know what design or hope he had for this hour."[36] For his part, Frodo ponders "everything that he could remember of Gandalf's words."[37] The same thing happens later at the Black Gate, where Frodo finds that there is no passable way into Mordor and Gollum offers to lead him up the stairs of Cirith Ungol. There Frodo "sat upon the ground for a long while, silent, his head bowed, striving to recall all that Gandalf had said to him. But for this choice he could recall no counsel. Indeed, Gandalf's guidance had been taken from them too soon, too soon."[38]

Guidance for making choices is not the only help that Gandalf has to give. Like the biblical prophets, he foresees the future. "I can see many things far off," Gandalf says to the dwarf Gimli in the Forest of Fangorn.[39] According to Treebeard, this is "the business of Wizards": they "are always troubled about the future."[40] Perhaps the most significant example is Gandalf's true prophecy that before the quest could be completed, Gollum would fulfill some vital role: "My heart tells me that he has some part to play yet, for good or ill,

[35] *FR*, 322.
[36] *FR*, 387.
[37] *FR*, 388.
[38] *TT*, 630.
[39] *TT*, 484.
[40] *TT*, 461.

before the end."[41] In the event, Frodo remembers the wizard's prophecy and says, "But do you remember Gandalf's words: *Even Gollum may have something yet to do?* But for him, Sam, I could not have destroyed the Ring. The Quest would have been in vain, even at the bitter end."[42]

The value of Gandalf's foresight does not lie chiefly in the avoidance of danger. If safety were the purpose of his prophecies, then, as Gimli observes, Gandalf's "foresight failed him." For although he was in favor of their journey, he was "the first to be lost."[43] Aragorn had foreshadowed the wizard's doom when he told the rest of the Fellowship that Gandalf would lead them out of Moria "at whatever cost to himself."[44] On later reflection, the Ranger judges the wizard's foresight by a higher standard than self-preservation: "The counsel of Gandalf was not founded on foreknowledge of safety, for himself or others. There are some things that it is better to begin than to refuse, even though the end may be dark."[45]

More than telling the future—to whatever end—Gandalf sees the present in true perspective, and this too is a prophetic gift. Although the biblical prophets are perhaps best known for their predictive prophecies, the preponderance of their ministry involves speaking uncomfortable truths about the present situation. What distinguishes Gandalf most is his gift of discernment. In his wide travels throughout Middle-earth, the wizard seeks to perceive what is happening in the great struggle between good and evil.

Gandalf first offers the gift of discerning the times to Frodo when he is back at Bag End, still at home in the Shire. As the

[41]*FR*, 58; cf. 249.
[42]*RK*, 926.
[43]*TT*, 430.
[44]*FR*, 303.
[45]*TT*, 430.

wizard carefully explains the rise of Sauron's shadow, the unique power of the One Great Ring, and the wider state of affairs in Middle-earth, Frodo understandably wishes that none of these things had transpired in his own time. "So do I," Gandalf replies, "and so do all who live to see such times. But that is not for them to decide. All we have to decide is what to do with the time that is given us."[46]

This is Saruman's great error—the White wizard who imprisons Gandalf and betrays the Council of the Wise. Each of the protagonists in *The Lord of the Rings* has a foil, a contrasting character who highlights their true qualities. Gollum serves as a foil for Frodo, Boromir for Aragorn, and so on. For Gandalf, the contrasting character is Saruman. They are "like and yet unlike," Gimli says, and in the end Gandalf becomes Saruman "as he should have been."[47] Both wizards recognize that a great change is coming to Middle-earth. The time of the elves is passing, which Saruman sees as a chance to seize power. "Our time is at hand," he says: "the world of Men, which we must rule. But we must have power, power to order all things as we will, for that good which only the Wise can see."[48] Sadly, Saruman never does see the good, despite Gandalf's best efforts to win him over. The wizard finds more success with Théoden, the king of Rohan who falls under Saruman's spell. When Gandalf unmasks this evil, Théoden finally is able to see things as they are. "Indeed," he says, "my eyes were almost blind."[49]

It should hardly come as a surprise that Gandalf's words— prophetic and otherwise—sometimes fall on deaf ears. This is the sad fate of prophets everywhere: they are rarely treated with

[46] *FR*, 50.
[47] *TT*, 564, 484.
[48] *FR*, 252.
[49] *TT*, 510.

honor, either in their hometown or elsewhere. In Rohan, Gandalf is regarded as a harbinger of bad news. "Gandalf Stormcrow," the king calls him—"a bringer of evil" and "a herald of woe."[50] In Gondor, Lord Denethor makes similar complaints about the wizard's unwelcome habit of coming to him with tidings of grief and danger. "Some have accused you," Denethor says, "of delighting to bear ill news."[51]

Part of Gandalf's rejoinder is that he only comes when help is needed. "Yet in two ways may a man come with evil tidings," he says to King Théoden. "He may be a worker of evil; or he may be such as leaves well alone, and comes only to bring aid in time of need."[52] Besides, the bad news that Gandalf brings happens to be true news that needs to be heard. At Rivendell, when the wizard speaks of the dark power that "is again stretching out over the world," Pippin wryly remarks that he "has been saying many cheerful things like that."[53] Bilbo—who on occasion had called Gandalf "an interfering old busybody"[54]—later observes that although the wizard almost never gives pleasant advice, it always turns out to be good advice.[55] Evidently, the wisdom of prophets only seems wise to the wise.

Similarly, the consolation of prophets only brings courage to the courageous. When Théoden wallows in gloomy despair, Gandalf points to a patch of bright sky shining through a high window and says, "Not all is dark. Take courage, Lord of the Mark; for better help you will not find. No counsel have I to give to those that despair. Yet counsel I could give, and words I could speak to you. Will

[50] *TT*, 425, 501.
[51] *RK*, 801; cf. 733.
[52] *TT*, 502; cf. *RK*, 733.
[53] *FR*, 220.
[54] *FR*, 31.
[55] *FR*, 263.

you hear them?"[56] So the effect of Gandalf's counsel depends on something more than the wisdom of his words; it depends as much on the hearts of his hearers, which are revealed by their responses. The wizard says something similar when he reaches the outskirts of Minas Tirith and finds the guards working to repair the outer wall: "Courage will now be your best defence against the storm that is at hand—that and such hope as I bring. For not all the tidings that I bring are evil."[57]

The companions who take courage from Gandalf's words are helped by what he says. One such companion is Aragorn son of Arathorn. "I have spoken words of hope," Gandalf says to Gondor's rightful king. "But only of hope. Hope is not victory."[58] These words are intended to give Aragorn hope, but also to spur him on to the kind of courageous action that may help to win the war for Middle-earth.

In the end, it is Gandalf's wise words—more than anything else—that gain the victory over the black powers of Mordor. "He has been the mover of all that has been accomplished," says Aragorn, "and this is his victory."[59] In his summary "Of the Rings of Power and the Third Age," published in *The Silmarillion*, Tolkien concludes by saying, "Now all these things were achieved for the most part by the counsel and vigilance of Mithrandir, and in the last few days he was revealed as a lord of great reverence, and clad in white he rode into battle."[60]

Even when Gandalf rides into battle, words are his primary weapon. "You cannot pass!" he says to the Balrog. He gives a similar rebuke when the Lord of the Nazgûl breaks down the Gate of

[56] *TT*, 503.
[57] *RK*, 733.
[58] *TT*, 489.
[59] *RK*, 946.
[60] *Sil*, 304.

Gondor and seeks to capture the city: "You cannot enter here. Go back to the abyss prepared for you! Go back! Fall into the nothingness that awaits you and your Master. Go!"[61] The wizard's rebuke to the Messenger of Mordor at the Black Gate Morannon is even more dismissive: "As for your terms, we reject them utterly. Get you gone, for your embassy is over and death is near to you. We did not come here to waste words in treating with Sauron, faithless and accursed; still less with one of his slaves. Begone!"[62]

Much more could be said about the wise words of Gandalf the Grey. He issues words of warning, such as "Beware of [Saruman's] voice!"[63] He has the wisdom to interpret the meaning of people's dreams.[64] He unfolds ancient mysteries and answers curious questions—at least when he has the patience for it. Witness Pippin's astonished delight when he rides with Gandalf to Minas Tirith and gets answers to many of his questions, wondering all the while how long this will last.[65] And at the critical moment of the last great battle, when Gandalf perceives that the Ring finally has been cast into the fires of Mount Doom, his voice pronounces his enemy's doom: "The realm of Sauron is ended!"[66]

Recounting Gandalf's words enables us to highlight a crucial principle in his rules of engagement: although he always has the freedom to give counsel, and although in moments of grave danger he is permitted to rescue those in peril, by the terms of his calling he is not permitted to exercise mastery over lesser creatures or to gain victory by means of superior strength. We know this from one of Tolkien's letters, in which he explains that the wizards were sent

[61]*RK*, 811.
[62]*RK*, 872.
[63]*TT*, 563.
[64]*TT*, 655.
[65]*TT*, 583.
[66]*RK*, 928.

primarily to "train, advise, instruct, arouse the hearts and minds of those threatened by Sauron to a resistance with their own strengths; and not just to do the job for them."[67] Similarly, in one of his lengthy appendixes the author writes, "It was afterwards said that they came out of the Far West and were messengers sent to contest the power of Sauron, and to unite all those who had the will to resist him; but they were forbidden to match his power with power, or to seek to dominate Elves or Men by force and fear."[68]

Perhaps the clearest example of Gandalf obeying this commission comes in his long conversation with Frodo at the beginning of the trilogy. As Frodo begins to grasp the dangers that the Ring poses, he wishes that it had never been found, never kept, and never given to him. "Why did you let me keep it?" he asks Gandalf. "Why didn't you make me throw it away, or, or destroy it?"[69]

Gandalf's response seems almost whimsical: "Let you? Make you? Haven't you been listening to all that I have said? You are not thinking of what you are saying."[70] Later, when Frodo insists that he was "not made for perilous quests" and instead asks the wizard to take the Ring and protect it with all his power and wisdom, Gandalf springs to his feet and renounces the temptation to gain any more power than he already has. "The decision lies with you," he finally says to Frodo. "But I will always help you."[71] In keeping with his calling as a messenger to Middle-earth, the help that Gandalf gives is never coercive but always respects the free choice of other creatures.

One limitation that Gandalf does not face is mortality: the wizards do not die but go on living in Middle-earth from age to

[67]Tolkien, *Letters*, 202 (no. 156).

[68]*RK*, 1059.

[69]*FR*, 58.

[70]*FR*, 58.

[71]*FR*, 160.

age. Yet Tolkien contrives to have Gandalf pass through a sequence of death, resurrection, and transfiguration. This is one of the most deeply Christian aspects of his accomplishment in *The Lord of the Rings*: each of Tolkien's three main protagonists lays down his life, only to take it up again and then become immortal.

Gandalf meets his "death" when the Balrog poses a challenge he has never faced before: an evil presence as "dark as a cloud was blocking out all light."[72] Although the wizard is able to resist this deadly force long enough to enable his friends to escape, the demon grabs him by the leg and drags him down into the mountain's darkest depths. According to Tolkien, although the nature of Gandalf's descent into death remains somewhat mysterious, it truly was a sacrifice for him "to perish on the Bridge in defence of his companions." The wizard's heroic act was nothing less than "a humbling and abnegation of himself" because "for all he could know at that moment he was the *only* person who could direct the resistance to Sauron successfully," and therefore at that moment his mission was in vain: he was "giving up personal hope of success."[73] His traveling companions grieve deeply, believing that they will never see their friend again and knowing that the loss of his aid threatens their very survival. Having seen Gandalf fall into the abyss, Frodo (for one) believes that he is "gone, gone for ever into the shadow of Moria."[74]

But Gandalf turns out not to be dead after all, for after he sacrifices himself, he is—in Tolkien's words—"accepted, and enhanced, and returned."[75] Once he is reunited with Aragorn,

[72]*FR*, 319.
[73]Tolkien, *Letters*, 202 (no. 156).
[74]*TT*, 630.
[75]Tolkien, *Letters*, 202 (no. 156).

Gimli, and Legolas, the wizard describes his mysterious journey. Long he fell into fire, and then into deep water, where all was dark. "Cold it was as the tide of death," Gandalf said: "almost it froze my heart."[76] Yet even Moria's virtual tomb proved to have "a bottom, beyond light and knowledge," where "the world is gnawed by nameless things." There Gandalf wrestled against the deadly beast until the wizard and the Balrog came to an Endless Stair that climbed "from the lowest dungeon to the highest peak." There, on a pinnacle of fire and ice, Gandalf threw down his ancient enemy. "Then darkness took me," he tells his friends, "and I strayed out of thought and time, and I wandered far on roads that I will not tell."[77] Such was Gandalf's passage through the underworld, where "his old life burned away."[78]

Upon his return, his friends see him as an old man and fail at first to recognize him. In a scene reminiscent of the first resurrection appearances of Jesus Christ (e.g., Jn 20:11-18; Lk 24:13-35), Gandalf is veiled from their sight. But suddenly they know him again and see his dazzling splendor: "His hair was white as snow in the sunshine; and gleaming white was his robe; the eyes under his deep brows were bright, piercing as the rays of the sun; power was in his hand."[79] "Gandalf the Grey" has become "Gandalf the White,"[80] and on his magnificent white horse he would be known as "the White Rider."[81] When Aragorn sees him "shining as if with some light kindled within," he says, "We have One, mightier than [the Nine Riders of the Dark Lord]: the White Rider. He has passed through the fire and the abyss, and they shall fear him. We

[76] *TT*, 490.
[77] *TT*, 491.
[78] *RK*, 928.
[79] *TT*, 483-84.
[80] *TT*, 513, 576.
[81] *TT*, 530.

will go where he leads."[82] Gimli's encomium parallels the gospel even more closely. "Gandalf's head is now sacred," the dwarf says.[83] And later, when Gandalf confronts Saruman at the Tower of Orthanc, he says, "Behold, I am not Gandalf the Grey, whom you betrayed. I am Gandalf the White, who has returned from death."[84] In his saving death and glorious resurrection, Gandalf has become—like Christ—a prophet who died and rose again.

Gandalf's transformation—indeed, his transfiguration—gives fresh courage to the free people of Middle-earth. When the Black Riders visit despair on Minas Tirith, Pippin finds hope in the wizard's passage from death to life: "Gandalf fell and has returned and is with us. We may stand, if only on one leg, or at least be left still upon our knees."[85] High up in the Citadel, where in despair Lord Denethor compels his servants to prepare his funeral pyre, Gandalf's appearance is "like the incoming of a white light into a dark place."[86] But the most famous response comes from Samwise Gamgee: "Gandalf! I thought you were dead! But then I thought I was dead myself. Is everything sad going to come untrue?"[87]

THE THREEFOLD OFFICE
OF THE COLLEGE PRESIDENT

One of the high purposes of fantasy is to help us live more wisely in reality. Indeed, C. S. Lewis took this to be one of "the main things" that Tolkien "wants to say"—namely, "that the real life of men" is of "mythical and heroic quality." "The value of myth," Lewis goes on to say, "is that it takes all the things we know and

82 *TT*, 490.
83 *TT*, 492.
84 *TT*, 569.
85 *RK*, 749.
86 *RK*, 834.
87 *RK*, 930.

restores to them the rich significance which has been hidden by the 'veil of familiarity.'" By "dipping" the real things in myth, "we see them more clearly."[88] So what might we be able to learn from Gandalf's ministry as prophet—from his miraculous wonders, bold predictions, wise counsel, and triumph over death?

I have a special and specific reason for asking this question. I believe that the role of prophet—like the roles of king and priest—is part of my calling as the president of a Christ-centered college. I do not have the easiest job in the world. Economic turmoil, technological innovation, rapid globalization, increased government regulation, media scrutiny, public skepticism about the mission of higher education, student unrest, the volatile climate of social media, and the sheer complexity of campus life in the twenty-first century all require exceptional management, expansive vision, and enormous stamina. Thus I can relate to the rather pessimistic conclusion that the University of Virginia's Brian Pusser reached on the basis of his research for the Association of Governing Boards of Universities and Colleges. Today's college presidents, Pusser said, have been put in the "untenable position" of being asked to fulfill an office that is "mutating beyond the ability of anyone to do the job."[89] College and university presidents are looking for all the help that they can get, and one good place to find it is in the threefold office of Jesus Christ.

This idea has a long but forgotten history in American higher education. In his history of divinity at Harvard College, George Huntston Williams shows that Charles Chauncy, Increase Mather, and other presidents from Harvard's early decades viewed their office in

[88]C. S. Lewis, "The Dethronement of Power," *Time and Tide*, October 22, 1955, 1374.
[89]Brian Pusser, "AGB-UVA Symposium on Research and Scholarship in Higher Education," *Occasional Paper No. 41* (Washington, DC: Association of Governing Boards of Universities and Colleges, September 2000), 13-14.

continuity with the ministry of Elijah and Elisha, who led "the School of the Prophets" in ancient Israel.[90] Thus the president of Harvard was a prophet (although not, in their understanding, a priest or a king).

According to Williams, the association of the prophetic office with the academy has a "long history of imparting a high Christian sanction to university education." Employing the *munus triplex* was not original to Harvard but went as far back as Alexander of Roes, who in the thirteenth century distinguished the prophetic calling of the academy from the priestly calling of the church and the kingly calling of government.[91] The distinctions between these three offices were dramatized across the New England landscape by towns that featured a school, a church, and a town hall on their commons—the school represented the prophet, the church represented the priest, and the town hall represented the king.[92]

Although the New England schema makes good sense, we may also view a college president as fulfilling all three offices. The office of the president has prophetic, priestly, and kingly dimensions. By widening their perspective to include all three of these offices, today's Christian college and university presidents may properly view their sacred work as something they have been divinely anointed to accomplish. But they are not alone in this high calling. As we will see more clearly in the next chapter, every Christian is called to be a prophet, a priest, and a king. This is true for fathers and mothers, doctors and lawyers, scholars and

[90]George H. Williams, *Wilderness and Paradise in Christian Thought: The Biblical Experience of the Desert in the History of Christianity and the Paradise Theme in the Theological Idea of the University* (New York: Harper, 1962), 143-47.

[91]George H. Williams, *Divinings: Religion at Harvard from Its Origins in New England Ecclesiastical History to the 175th Anniversary of the Harvard Divinity School, 1636–1992*, vol. 1, *First Light: The Formation of Harvard College in 1636 and Evolution of a Republic of Letters in Cambridge*, ed. Rodney L. Peterson (Gottingen: Vandenhoeck & Ruprecht, 2014), 111.

[92]Ibid., 108-9.

teachers, bussers and businesspeople, even students and room-mates.[93] According to our various callings, we all have some re-sponsibility to speak prophetic words, offer priestly service, and exercise kingly authority.

ALLEGORY AND APPLICABILITY

Thus the question "What can we learn from Gandalf's ministry as prophet?" is relevant for all of us. But first we need to ask whether this way of reading *The Lord of the Rings* is even legitimate. There are good reasons to be cautious. Even a brief survey of the literary criticism—such as the survey that Paul Kerry provides in the introduction to his book *The Ring and the Cross*[94]—shows that many Christian scholars have tried their hand at Tolkien's magnum opus. The abundant variety of their approaches to the trilogy shows how robustly Christian the books are, but it also warns us to be careful about the claims we make for any particular perspective. My reading of Tolkien is only one reading, not the only reading or even the only Christian reading.

Furthermore, Tolkien's work has many pagan as well as Christian influences. If anything, the imaginative world that we enter when we read *The Lord of the Rings* is *pre*-Christian. Middle-earth is not a different world but our own world at a dif-ferent time—a time before Christ. It is a setting, writes one critic, in which "the ascendancy of the new Christian order *is not yet complete*."[95] In the author's own words, "The Fall of Man is in the

[93]See, for example, David Setran, "Priests and Prophets in the Home: Cotton Mather and Parental Prayer," *Journal of Spiritual Formation and Soul Care* 8, no. 1 (2015): 28-52, and Julius J. Kim and Phillip H. Kim, "Three Offices and the Entrepreneur: How the Church Community Helps the Business Leader Do Well by Doing Good" (Philadelphia: Center for Christian Business Ethics Today, 2010).

[94]Paul E. Kerry, *The Ring and the Cross: Christianity and "The Lord of the Rings"* (Lanham, MD: Fairleigh Dickinson University Press, 2011), 17-53.

[95]Janet Blumberg, quoted in ibid., 30 (italics original).

past and off stage; the Redemption of Man in the far future."[96] This helps to explain why Tolkien told W. H. Auden that he did not "feel under any obligation" to make his story "fit with formalized Christianity."[97] To put anything explicitly Christian into the story would be anachronistic.

Introducing explicitly Christian elements into a story would also be contrary to Tolkien's sensibilities as an author. His antipathy to allegory is well known. In his foreword to the second edition of *The Lord of the Rings* Tolkien wrote, "As for any inner meaning or 'message,' it has in the intention of the author none. It is neither allegorical nor topical. . . . I cordially dislike allegory in all its manifestations, and always have done so since I grew old and wary enough to detect its presence."[98] Elsewhere, he expressed his aversion to writing anything like "a parody of Christianity."[99]

This was the problem that Tolkien had with the Arthurian legends (and also with the Chronicles of Narnia by C. S. Lewis). The stories of King Arthur made the fatal mistake, as Tolkien saw it—he writes about this in a letter to Milton Waldman, his editor at Collins—of bringing historical elements of the Christian religion explicitly into the narrative. Tolkien believed that "myth and fairy-story must, as all art, reflect and contain in solution elements of moral and religious truth (and error)." But the presence of religion should not be explicit, he said, "not in the known form of the primary 'real' world."[100]

[96]Tolkien, *Letters*, 387 (no. 297).

[97]Ibid., 355 (no. 269).

[98]*FR*, xiv-xv.

[99]J. R. R. Tolkien, *Morgoth's Ring: The Later Silmarillion, Part 1, The Legends of Aman*, ed. Christopher Tolkien (Boston: Houghton Mifflin, 1993), 356. See also Tolkien's draft response to the *New Republic*, in which he insisted that there is "*no* 'allegory' . . . in the work at all" (*Letters*, 232 [no. 181]).

[100]*Sil*, xii.

Given these comments, it comes as something of a surprise to learn how carefully Tolkien selected the date for Sauron's downfall. The Ring was destroyed on March 25, which happens to be the traditional date for the Annunciation (nine months before Christmas) and also for the Crucifixion.[101] As a practicing Catholic, Tolkien was more than familiar with this tradition, and as a man nearly as interested in chronology as he was in etymology, he made good use of the calendar. Evidently, he chose this date to present his narrative as a forerunner to the gospel. Indeed, in a brief essay titled "Nomenclature of *The Lord of the Rings*," Tolkien confided that March 25 was "intentionally chosen by me."[102]

What is far more significant, though, is the way that Christian themes pervade Tolkien's narrative world. Ralph C. Wood rightly judges that "the religious significance of *The Lord of the Rings* thus arises out of its plot and characters, its images and tone, its landscape and point of view—not from heavy-handed moralizing or preachifying."[103] The result, explains novelist Michael O'Brien, is that "*The Lord of the Rings* trilogy is irradiated by the unspoken, unseen presence of Christ."[104]

Tolkien would agree. On more than one occasion the author admitted that "the more 'life' a story has"—and what story has more "life" in it than *The Lord of the Rings*?—the more readily its readers will draw connections to their convictions or interpret its

[101]See *RK*, appendix B, 1069.

[102]J. R. R. Tolkien, "Nomenclature of *The Lord of the Rings*," ed. Christopher Tolkien, in *A Tolkien Compass: Including J.R.R. Tolkien's Guide to the Names in "The Lord of the Rings,"* ed. Jared Lobdell and Clyde S. Kilby (LaSalle, IL: Open Court, 1975), 201. It is also noteworthy that the Fellowship of the Ring departed Rivendell on the equally auspicious date of December 25.

[103]Ralph C. Wood, *The Gospel According to Tolkien: Visions of the Kingdom in Middle-Earth* (Louisville, KY: Westminster John Knox, 2003), 5.

[104]Michael O'Brien, interview in *The Catholic World Report*, December 2001, 42.

meaning in ways that reinforce their beliefs.[105] He also believed deeply in his calling as a "sub-creator," a creature who imitated his Creator in making new worlds.[106] These new worlds inevitably reflected the character of the author. "It is I suppose impossible," Tolkien confided to W. H. Auden, "to write any 'story' that is not allegorical in proportion as it 'comes to life.' Since each of us is an allegory, embodying in a particular tale and clothed in the garments of time and place, universal truth and everlasting life."[107]

The story that any sub-creator writes also reflects, in turn, the character of God as Creator. Thus, in a conversation with Clyde S. Kilby, Tolkien claimed that "God is the Lord, of angels, and of man—and of Elves. Legend and History have met and fused."[108] If this is true, then the imaginative world of Middle-earth is under—not outside—the lordship of Jesus Christ.

The principle of sub-creation explains why, despite his protests against explicit Christian meanings, Tolkien could also say to a correspondent, "I am a Christian (which can be deduced from my stories) and in fact a Roman Catholic."[109] There is no contradiction here between both denying and admitting that *The Lord of the Rings* is in some sense a Christian book; what we see instead is Tolkien's "contrasistency," as Kilby called it.[110] In another letter Tolkien wrote, "*The Lord of the Rings* is of course a fundamentally religious and Catholic work; unconsciously so at first but consciously in the revision. I . . . have cut out practically all references

[105] *Sil*, xiii.
[106] J. R. R. Tolkien, "On Fairy-Stories," in *Tree and Leaf* (London: HarperCollins, 2001), 46-56. See also Colin S. Duriez, "Sub-creation and Tolkien's Theology of Story," in *Scholarship and Fantasy: Proceedings of the Tolkien Phenomenon, May 1992, Turku, Finland*, ed. K. J. Battarbee, Anglicana Turkuensia 12 (Turku, Finland: University of Turku, 1993).
[107] Tolkien, *Letters*, 212 (no. 163).
[108] Clyde S. Kilby, *Tolkien & "The Silmarillion"* (Wheaton, IL: Harold Shaw, 1976), 55.
[109] Tolkien, *Letters*, 288 (no. 213).
[110] Kilby, *Tolkien & "The Silmarillion,"* 55.

to anything like 'religion,' to cults and practices in the imaginary world. For the religious element is absorbed into the story and the symbolism."[111] Another way to say this is that in *The Lord of the Rings*, as grace penetrates nature, Christianity becomes incarnate.

If Tolkien is right, and Christianity is absorbed into his story, then we should expect to find Christ present in many places—not allegorically but inherently—including in the character of Gandalf. This is not to suggest that somehow Tolkien had all of these connections in mind. To reach this conclusion would be to overread the text and fall prey to Wimsatt and Beardsley's intentional fallacy.[112] Nor would it be true to Tolkien's experience as an author. For him, "the mere stories were the thing. They arose in my mind as 'given' things . . . yet always I had the sense of recording what was already 'there,' somewhere: not of 'inventing.'"[113]

Tolkien also came to understand that in what he called a "closely woven" story, "Allegory and Story converge, meeting somewhere in Truth."[114] This meant that, whatever his intentions as a writer, people who entered the world of his stories naturally would find connections to their own world. Thus Tolkien drew a distinction between "allegory"—which, as we have noted, he disliked or even despised—and "applicability," which he positively encouraged. In his foreword to the second edition of *The Lord of the Rings*, he wrote, "I think that many confuse 'applicability' with 'allegory'; but the one resides in the freedom of the reader, and the other in the purposed domination of the author."[115]

[111]Tolkien, *Letters*, 172 (no. 142).

[112]William K. Wimsatt and Monroe C. Beardsley, "The Intentional Fallacy," *Sewanee Review* 54 (1946): 468-88.

[113]*Sil*, xii.

[114]Tolkien, *Letters*, 121 (no. 109).

[115]*FR*, xv.

LESSONS LEARNED

In these Hansen Lectures, I am exercising the freedom of applicability by drawing connections between the characters, events, and themes of *The Lord of the Rings* and the Christian faith that formed the core of Tolkien's convictions. To read his fantasy is not to retreat from real life but to rediscover it. So consider, briefly, several lessons that college presidents and other leaders can draw from Gandalf the Grey and then apply to the prophetic dimension of our own callings.

Gandalf teaches us not to be afraid to say what needs to be said, even in the face of opposition. A prophet always speaks the truth, according to circumstance. There is a time to encourage but also a time to correct; a time to warn as well as a time to console. Thus a prophet's words are not always welcome. Indeed, Jesus was mocked in his prophetic office right up to his crucifixion. Some of his tormentors spat in his face, slapped him, and said, "Prophesy to us, you Christ! Who is it that struck you?" (Mt 26:68). Yet in his dying hours he continued to speak the truth, using his very cross as a pulpit. So too when we are called to speak the truth, we should speak it forthrightly, as Jesus did, and as Gandalf did, to both friends and enemies. At a time of declining biblical and theological literacy, the church, the academy, and the wider society all need leaders who are able to communicate biblical truth.

At the same time, Gandalf teaches us to beware the temptations that come with greater power and growing influence. The wizard is a person of immense power, which he is not afraid to use, especially when his friends are in danger. But he steadfastly resists any temptation to use this power for his own purposes—even when he is pressed urgently to do so. Gandalf dismisses Saruman's invitation

to become the co-regent of Middle-earth[116] and refuses outright when Frodo offers him the One Ring of Power.[117] "I do not trust myself in this," he tells Lord Denethor, so "I refused this thing, even as a freely given gift."[118] Gandalf's healthy mistrust of his strength to handle more power than he should preserves the purity of his prophetic voice.

Here is another, closely related lesson to apply: we should not use our words to coerce people, but instead we should respect people's God-given freedom to make their own choices in life. This lesson is especially important for parents, teachers, pastors, counselors, and anyone else who is given the care of souls. Simply put, we need to be careful not to "play God" for other people. Even if we know the truth, as Gandalf does, we need to respect the freedom of others to draw their own conclusions and make their own choices—even if some of those choices and conclusions seem wrong to us. Gandalf is careful to obey the rules of his calling, and one of the rules for us is not to make decisions for other people or manipulate them to make the decisions we think they ought to make.

This principle is hard for most parents to understand, and also for others who want to see the Christian college play a parental role and don't always like the decisions that students, faculty, or administrators make. Tolkien rightly understood that evil and the Enemy are the ones who want to dictate and dominate.[119] The college's role is to guide and to educate—a prophetic role that gives the members of a campus community broad freedom to make their own decisions, including decisions that turn out to be mistakes.

[116]*TT*, 567-68.
[117]*FR*, 60.
[118]*RK*, 797.
[119]See *Sil*, xiii-xiv.

Finally, Gandalf teaches us to speak words of hope in desperate times.[120] Sooner or later, we all have difficult experiences in life, when hope is the only thing that sustains us and words of encouragement mean more to us than life itself. But thinking more broadly, we all live in desperate times, as Gandalf did. The influence of Christianity seems to be declining in America and the West. At the same time, opposition to Christianity seems to be increasing—not only in this country but also around the world—and this makes some Christians pessimistic about the future. Many can relate to the words of Aragorn: "So we come to it in the end; the great battle of our time, in which many things shall pass away."[121] Others are tempted to take up Théoden's lament: "Alas! That these evil days should be mine, and should come in my old age instead of that peace which I have earned. Alas for Boromir the brave! The young perish and the old linger, withering."[122] Fortunately for Théoden—and his followers—Gandalf is there to correct his royal self-pity and strengthen his courage. The wizard calls the old king to "cast aside regret and fear" and "do the deed at hand,"[123] which Théoden does.

Gandalf's good words often had a life-giving effect on people. During Gondor's last defense, it was said that "wherever he came men's hearts would lift again."[124] This is what good leaders do: they strengthen people's souls. This takes something more than discerning the times, or even knowing what needs to be done; it takes wisdom to give people the will to face what they must. It also takes courage—the courage to do one's duty, come what may. On the eve of battle, Gandalf strengthens Pippin's heart by saying, "All worthy

[120]See David Rozema, "*The Lord of the Rings*: Tolkien, Jackson, and 'The Core of the Original,'" *Christian Scholar's Review* 37, no. 4 (Summer 2008): 437-40.
[121]*RK*, 784.
[122]*TT*, 505.
[123]*TT*, 507.
[124]*RK*, 806.

things that are in peril as the world now stands, those are my care. And for my part, I shall not wholly fail of my task, though Gondor should perish, if anything passes through this night that can still grow fair or bear fruit and flower again in days to come."[125]

Like the Free Peoples of Middle-earth, we live at a time when "all realms shall be put to the test, to stand, or fall—under the Shadow."[126] Christians always live in such times, as we wait for the return of our King. In the meantime, God has given us the ministry of prophets, not only to help us discern the times, but also to give us the strength to persevere. Whatever good work God has given each of us to do is sure to be a struggle, for whenever one enemy falls, another one rises. But in the long struggle we must do our part, in our time. As Gandalf explained to Aragorn, "Other evils there are that may come; for Sauron is himself but a servant or emissary. Yet it is not our part to master all the tides of the world, but to do what is in us for the succor of those years wherein we are set, uprooting the evil in the fields that we know, so that those who live after may have clean earth to till."[127]

[125] RK, 742.
[126] RK, 749.
[127] RK, 861.

Response

SANDRA RICHTER

There are two stories that I know better than I know my own—two narratives in which I have wrapped my life and that have made me better than I am. These epic tales sang a new song to this broken heart and have over and over again given me the courage and vision to pursue a life beyond the status quo, a dream beyond the darkness. The most influential of these is the great story, the story of redemption. The ongoing saga of a heavenly Father who cannot, will not, rest until he seeks and saves his own. The story of a God who stands at the gate of death and says, "Let my people go." This is the most influential of the two. But it was not the first.

Rather, the *first* gospel I heard was that of a king, exiled from his throne. One who, although the heir of Númenor, had taken the form of a vagabond and, being found in the appearance of a Ranger, lived out his life on the margins of his own lawful inheritance, tirelessly laboring to undermine the enemy that held his citizenry captive. Who, regardless of the cost, strove without ceasing to seek and save a kingdom that seemed destined only for decline and defeat—all for the sake of a populace who had no idea who he truly was. This of course is Aragorn, son of Arathorn, Elendil's heir. And it was this man and his fellows, including Frodo the nine-fingers and Gandalf the White, who prepared my heart to hear the story of another King, destined to rule, whose outward appearance gave no hint of his royal lineage but who in truth was the heir apparent of the kingdom of God.

In this piece, President Ryken demonstrates that I am not the only one who has heard the gospel and met the King in the epic tale of *The Lord of the Rings*. Ryken argues that the threefold office of the Christ can be located in the three great heroes of the saga of Middle-earth—Gandalf the prophet, Frodo the priest, and Aragorn the king.

Our first question is, whence comes this threefold office of the Christ that President Ryken is using as an analog for the threefold ministry of the college president and indeed the calling of every Christian? The obvious answer as affirmed by every writer of the New Testament is that this threefold office of the Christ emerges from the threefold office of the theocracy of ancient Israel. The analog is first alluded to in the opening genealogy of the Gospel of Matthew (Mt 1:1-17) and is brought to its climax by the author of Hebrews (Heb 1:1-6; 4:14-16). Indeed, the threefold "theocracy" of God's kingdom is one of the core types of the Old Testament intended to foreshadow the coming truths of the New.

What is a theocracy? The word itself emerges from the Greek words for "God," *theos*, and "to rule," *krateō*, and communicates the nature of ancient Israel's federal government. Yahweh ruled Israel, enthroned above the cherubim from his palace known in the Old Testament as the *bêt Yahweh* ("the house of temple of Yahweh"), making Israel the kingdom of God. So in Israel, the enemies of the state were in truth the enemies of God. The national borders of the state were the boundaries of the kingdom of God, and the citizens of the state were citizens of the kingdom of God. But who would rule this divinely directed kingdom? Yahweh was of course the great king, offering regular audience to his people. He sanctioned and directed holy war and received tribute and taxation from his citizenry. But who carried out his wishes in the everyday realities of running the society? The answer to this is found in the

constitution of the nation of Israel, the book of Deuteronomy. Here in chapters 16 through 18 we find the job descriptions of the three *human* officers of Yahweh's government: the prophet, priest, and king. The prophet spoke for God to the people, the priest spoke for the people to God, and the king was the civic leader and steward of Yahweh's kingdom.

As the descendants of monarchy ourselves, we might naturally assume that the king was the most powerful of these three officers. But we would assume wrongly, as Israel often did! It was in reality the prophet—as the heir of Moses, and Yahweh's representative to his vassal nation—who carried the most authority in Israel's government. The true prophet was indeed the "mouth of Yahweh." He was the king-maker and king-breaker, and his authority reigned supreme.

Nowhere is this dynamic demonstrated more eloquently than the prophet Nathan's confrontation with King David (2 Sam 12). Here David, the paradigmatic king of all Israel, has been found guilty of adultery, fraud, conspiracy, and murder. He has rewarded one of his "mighty men" with a most despicable betrayal of trust—sending a loyal and courageous man to his death in order to cover the king's own crimes. The story opens with David sitting enthroned in his palace, elevated above his citizenry, dressed as a royal, insulated against the agonies of regular life by his wealth and influence, with his armed men lining the walls of his audience chamber. Nathan enters unarmed. We should all be seeing Gandalf and Théoden here! And Nathan cries out from the floor—in public, in front of David's enlisted men—"You are the man! You stole, you cheated, you lied! That woman is not your own and that child will die!" I assure you that in any other throne room in the ancient Near East, that prophet would have died where he stood. But not in Yahweh's kingdom. For when the prophet spoke in Israel, God

spoke, and wise kings listened. So it was when Gandalf speaks as well—without summons, without license, without a weapon—demons tremble and the king obeys.

As President Ryken has demonstrated, like the prophet of Israel, Gandalf counsels kings with a wisdom that ultimately emanates from another kingdom, one beyond the ken or experience of the limited vision of the human kings of Rohan, Gondor, and beyond. The wizards are "messengers sent by the Lords of the West to contest the power of Sauron."[128] In their darkest days, these human kings of Middle-earth turn (willingly or not) to hear the wisdom of a singular cause that is above their own—a cause that, if secured, would deliver all of them from the greatest of threats. Unlike these human kings, Gandalf sees the true enemy, discerns his influence in places others may not, and stands by steadfast as first Frodo and then Aragorn, Elrond, Théoden, Faramir, and Treebeard are each overcome by their circumstances, terrified by their opponents, unsure of their own strength, and waver. Like King Hezekiah, each of these cries out in their moment of fear, "This is a day of distress, rebuke, and rejection; children have come to the point of birth but there is no strength to deliver!" (Is 37:3, author's translation). But like Isaiah, Gandalf steps to the fore, seizes the hand that trembles, and shouts out, "Take your stand. Hold your ground. If you believe, you will live. . . . Yahweh will defend this city and save it for His own sake and the sake of his servant David!" (Is 7:9; 37:35, author's translation). And so Gandalf, the eyes and voice of the Eldar, stands at Aragorn's side in that darkest of days at the entrance of the Black Gate. Outarmed, outmanned, standing in the heart of the Enemy's territory, Gandalf speaks truth into Aragorn's soul. It is Gandalf's vision that gives Aragorn the strength

[128] *Sil*, 299.

to lead his quaking troops to the very gates of Mordor: "As I have begun, so I will go on. We come now to the very brink, where hope and despair are akin. To waver is to fall. Let none now reject the counsels of Gandalf, whose long labors against Sauron come at last to their test. But for him all would long ago have been lost."[129] Indeed it is Aragorn's courage that stirs in these men the will to fight. But it is Gandalf's courage that stirs in Aragorn the will to lead.

All of us who know the story know that by strength of arms Aragorn doesn't stand a chance. Unless a power beyond their reach acts, Aragorn and the men of the West, who stand as martyrs at the gate of Mordor, will die. And we all know it. But a power beyond their reach does act. And just like with Hezekiah, standing on the walls of besieged Jerusalem, the impossible happens. The Dark Lord retreats, his sword is broken, and the king lives to fight another day.

What did a true prophet do in the Old Testament? Like Gandalf, he saw the world as it actually was. He came as the emissary of the true king and brought words of vision and wisdom, courage and hope to a constituency who for so many reasons could not see. The prophet brought the aroma of life to a world overcome with the stench of death. And he spoke the truth, regardless of how costly it might be. The parallels here to a Christian leader, specifically a college president, are obvious—and daunting. Of all the parallels I could affirm or expand on the basis of President Ryken's lecture, the one I am most eager to pursue comes from his final paragraphs. As he states, "This is what good leaders do: they strengthen people's souls." They strengthen people's souls. But for what? I would say to fulfill their *true* vocations. The prophet, privy to the divine council

[129]*RK*, 862.

of heaven, actually *saw* the plan of the Almighty. And speaking to kings or commoners, the prophet brought that vision into reality. As Dr. Ryken has said, Gandalf *saw* those he served with an uncommon vision. He saw in an everyday hobbit a hero of uncommon courage. He saw in an antiquated Ent a critical ally. He identified the peripheral and the essential and told Théoden to do the same. He allied dwarves, elves, hobbits, and men under a single banner. He urged them to resist the all-consuming objective of defending their own turf and convinced them to throw their shoulders behind a single wheel, the imperative of the calling of the kingdom. In sum, the true prophet spent his life empowering those around him to be great, so that the kingdom might prevail and the true enemy might be crushed. And as I, a simple hobbit with a divinely ordained calling, look to my president, I say, "Godspeed, President Ryken. We need you. We need your vision, we need your courage, we need you and those like you willing to take on the mantle of the prophet and strengthen people's souls for the cause of the kingdom."

2

FRODO, SAM, *and the* PRIESTHOOD *of* ALL BELIEVERS

At the foot of Amon Hen, on the western shores of the Great River, Anduin, the fate of the Fellowship of the Ring hangs in the balance. There has been a sharp disagreement over which direction to go next: straight into Mordor, where they may hope against hope to destroy the One Great Ring of Power once and for all, or else to the fragile safety of Minas Tirith, where perhaps they could make one last military stand against Sauron and the hosts of evil.

The decision lies with Frodo, the Ring-bearer, who needs more time to gather his thoughts, or at least to make the awful choice he knows that he must make. Boromir follows Frodo into the woods and foolishly makes a play for the Ring, which drives Frodo to action. The hobbit slips on the Ring, becomes invisible, and steals back to the boats, intending to continue down the river by himself and walk into Mordor alone.

When the rest of the Fellowship realizes that Frodo is missing, they run in eight directions at once to find him. Frodo's servant Samwise Gamgee suddenly realizes that his master must have

made up his mind to leave them behind. Sam runs back to the shore like lightning and arrives just in time to see one of the boats slide into the water, seemingly all by itself. "Coming, Mr. Frodo! Coming!" he shouts as he throws himself into the river and clutches after the boat. Sam, who can't swim, goes right under and needs to be rescued: "Save me, Mr. Frodo! I'm drownded."[1]

When Frodo manages to pull Sam to safety, the two hobbits argue about who is or isn't going to Mordor. Frodo believes that if his friend hadn't come back to the boats, he would be safely on his way already. "Safely!" says Sam. "All alone and without me to help you? I couldn't have a borne it, it'd have been the death of me." To which Frodo replies that it would be the death of Sam to go with him, for he is going to Mordor. "Of course you are," says Sam. "And I'm coming with you." Frodo will countenance no further delay and wants to leave at once. "But not alone," Sam insists. "I'm coming too, or neither of us isn't going."[2]

Sam's determination to stick with his master proves decisive in the Fellowship's quest to save Middle-earth. Without Sam, Frodo never would have reached Mount Doom, the Ring never would have been destroyed, and Sauron never would have been defeated. So the scene at the river Anduin is crucial to the plot.

Sam's steadfast commitment to Frodo helps us understand something vitally important about hobbits and about ourselves. Hobbits were never meant to bear their burdens alone; they only fulfill their purpose when they journey together. As Frodo concedes, "It is no good trying to escape you. But I'm glad, Sam. I cannot tell you how glad. Come along! It is plain that we were meant to go together."[3]

[1] *FR*, 396.
[2] *FR*, 397.
[3] *FR*, 397.

WHAT WOULD TOLKIEN SAY?

The fellowship of Frodo, Sam, and the other hobbits aptly illustrates the biblical doctrine of the priesthood of all believers as announced by Martin Luther: "Let everyone, therefore, . . . who knows himself to be a Christian, be assured of this, that we are all equally priests."[4] This is the second of three life-shaping doctrines that I wish to explore in these Hansen Lectures. My thesis is that the three central protagonists in *The Lord of the Rings*—Gandalf, Frodo, and Aragorn—offer us images of the threefold office of Jesus Christ as prophet, priest, and king.

In the previous chapter, we considered the life and work of Gandalf the Grey from the vantage point of prophetic ministry. By foreseeing the future, by issuing warnings and speaking other uncomfortable truths, and by strengthening people's courage through words of hope, Gandalf shows us how to serve as prophets in the kingdom of God. In the home, at church, in the academy and the marketplace, and in society generally, every Christian has a calling to speak God's truth.

In this chapter, we move on to consider Christ's priestly office and our own calling as a kingdom of priests. But first we need to ask again whether this way of looking at *The Lord of the Rings* is legitimate. For some literary critics, to read Tolkien's novel in Christian perspective is "essentially mistaken,"[5] because—as one of them writes—"Christ is carefully and laboriously excised" from Middle-earth.[6] This criticism may lead us to wonder what Tolkien would say about what we are doing. Is it appropriate to draw connections to biblical truth and practical Christianity from reading his trilogy?

[4]Martin Luther, "The Babylonian Captivity of the Church," in *Luther's Works: Word and Sacrament, II*, ed. Abdel Ross Wentz (Philadelphia: Muhlenberg, 1959), 36:116.

[5]Catherine Madsen, "Light from an Invisible Lamp: Natural Religion in *The Lord of the Rings*," *Mythlore* 53 (Spring 1988): 43-47.

[6]R. A. Lafferty, "Tolkien as Christian?," *Triumph* 9 (March 1974): 35-37.

From what the author sometimes said about his own work, the answer is a carefully qualified yes. For example, in a letter to the poet W. H. Auden, Tolkien wrote, "I don't feel under any obligation to make my story fit with formalized Christian theology, though I actually intended it to be consonant with Christian thought and belief."[7] So while we shouldn't expect to find any explicitly Christian teaching in *The Lord of the Rings*, we shouldn't be surprised to find some of the Bible's central truths in its pages.

Several well-known Tolkien scholars reached a similar conclusion in a public conversation at Wheaton College in 1979. C. S. Lewis's former student and sometime Inkling George Sayer was at the Wade Center that night and said,

> Tolkien, I found, very much objected to the view that he wrote his books as Christian propaganda or anything like it. He wrote them as stories. He would sometimes pull a bunch of American letters or reviews towards him and say, "You know, they're now telling me that . . ." and then he would say some of the things they'd told him about *The Lord of the Rings*. He'd say, "You know, I never thought of that. I thought I was writing it as pure story."

But Sayer went on to tell the audience that Tolkien "came gradually to believe some of the things that, well, you were telling him."[8] In other words, Tolkien recognized in his own work the real but unintended presence of biblical truth.

Wheaton College's Clyde S. Kilby—the longtime chair of the English department who became one of Tolkien's trusted friends—

[7]J. R. R. Tolkien, *The Letters of J.R.R. Tolkien*, ed. Humphrey Carpenter (Boston: Houghton Mifflin, 2000), 355 (no. 269).

[8]"A Dialogue: Discussion by Humphrey Carpenter, Professor George Sayer, and Dr. Clyde S. Kilby, Recorded September 29, 1979, Wheaton, Illinois," *Minas Tirith Evening-Star* 9, no. 2 (January 1980): 16-17.

was also part of the dialogue and agreed with Sayer: "Tolkien did not want his things interpreted as allegorical; but of course in his great, beautiful inconsistency, he did write an article and say, 'I don't see why people don't see God in my stories.' But Lewis can be allegorical, and Tolkien said to me once, 'Well, you can have significance without having allegory.'"[9] To see images of the Messiah in Middle-earth is one way to see the significance of *The Lord of the Rings*, and we may take this approach without mistakenly treating the novel as an allegory.

With respect to the threefold office of Christ, we can be even more specific. Sometime in the 1960s, Professor Barry Gordon at the University of Newcastle in Australia wrote an essay titled "Kingship, Priesthood, and Prophecy in *The Lord of the Rings*." The essay was never published, although it is now available in the university's digital archive.[10] In his analysis of *The Lord of the Rings*, Gordon seems to have been influenced by the French Catholic theologian Yves Congar, whose book *Laypeople in the Church* is an extended reflection on the prophetic, priestly, and kingly ministry of the church.[11] Gordon claims that there are "three chief aspects to the manner in which Christ acts to save the world." These are "a loving mastery that brings about a renewal of just order and harmony; . . . a self-sacrifice that effects an atonement and unleashes a flood of grace; and . . . his teachings which embody the truths necessary for salvation."[12] In short, Jesus Christ saves the world through his royal, priestly, and prophetic ministry.

[9]Ibid.

[10]Barry Gordon, "Kingship, Priesthood, and Prophecy in *The Lord of the Rings*" (unpublished paper, ca. 1967, University of Newcastle, Australia), https://downloads.newcastle.edu.au /library/cultural%20collections/pdf/Kingship_priesthood_prophecy_in_the_LOTR.pdf.

[11]Yves Congar, *Laypeople in the Church* (London: Chapman, 1959).

[12]Gordon, "Kingship," 1.

But further, according to Gordon, "this is the pattern of all Christian mediation" in the world. Once we are incorporated into the life of Christ through baptism, we lead "a life of redemptive activity," fulfilling "the Christian offices of kingship, priesthood, and prophecy." In this way, "each person, sharing in the person of Christ, may act as a co-saviour of the world." Gordon sees the same "schema," as he calls it, at work in *The Lord of the Rings*: "Middle-earth is saved through the priestly self-sacrifice of the hobbit, Frodo; through the wisdom and guidance of Gandalf the wizard; and through the mastery of Aragorn, the heir of kings."[13]

Somehow a copy of Gordon's essay came across Tolkien's desk, and we know what he thought about it from a note that he wrote to Clyde S. Kilby—a note that is preserved at the Wade Center.[14] Kilby imagined that some of Tolkien's readers would be horrified by Gordon's analysis, but the author had a rather different response. "Much of this is true enough," Tolkien acknowledged— "except, of course, the general impression given (almost irresistibly in articles having this analytical approach, whether by Christians or not) that I had any such 'schema' in my conscious mind before or during the writing."[15]

If Gandalf, Frodo, and Aragorn remind us in various ways of Jesus Christ, it is not because the novelist had this explicitly in mind. It is rather because a biblical worldview so thoroughly penetrated his imagination that inevitably it pervaded his literary art. Elsewhere Tolkien went so far as to say that "each of us is an allegory, embodying in a particular tale and clothed in the garments

[13]Ibid., 1-2.

[14]Letter from J. R. R. Tolkien to Clyde S. Kilby, ca. July 1966. J. R. R. Tolkien Letter collection, L-Kilby 4, The Marion E. Wade Center, Wheaton College, Wheaton, IL.

[15]Tolkien's note is quoted in Clyde S. Kilby, *Tolkien & "The Silmarillion"* (Wheaton, IL: Harold Shaw, 1976), 55-56.

of time and place, universal truth and everlasting life."[16] Our lives—and therefore our art—tell a story about eternal truth. So when Tolkien, for example, had one of his characters bear a heavy burden for the sake of a kingdom, it was only natural for the author to portray the burden shared by a fellowship of love that calls to mind the priesthood of all believers.

A DOCTRINE FROM THE REFORMATION

The doctrine of the priesthood of all believers was developed principally by the Protestant Reformers and thus is associated closely with the sixteenth-century Reformation in Europe.

As we saw in the previous chapter, Eusebius of Caesarea and several other church fathers celebrated the anointing of the Christ as prophet, priest, and king. This threefold doctrine was not developed thoroughly in the medieval period, although we do find Thomas Aquinas commenting in his *Summa Theologiae* that while "other men possess particular graces, being legislators or priests or kings," Jesus Christ "is all of these and the fount of all graces."[17]

Martin Luther's insight was to see that Christians are anointed to the same three offices as Christ. At first Luther focused only on the offices of priest and king (as had been common in the mainstream of medieval theology): "Just as Christ by his birth-right obtained these two prerogatives, so He imparts them to and shares them with everyone who believes on Him.... Hence we are all priests and kings in Christ, as many as believe on Christ."[18] Luther's

[16]Tolkien, *Letters*, 212 (no. 163).

[17]Thomas Aquinas, *Summa Theologiae: A Concise Translation*, ed. Timothy McDermott (London: Methuen, 1989), 3.22.1.

[18]Martin Luther, *Christian Liberty*, quoted in John Frederick Jansen, *Calvin's Doctrine of the Work of Christ* (London: James Clarke, 1956), 32-33; see also the brief historical survey of the medieval period on 26-29.

followers soon added "prophet" to the list. In his 1530 defense before the Diet of Augsburg, the Lutheran theologian Andreas Osiander reasoned as follows:

> Since Christ is called an Anointed One and only the prophets, kings, and high priests were anointed, one notes well that all three of these offices rightly belong to him: the prophetic office, since he alone is our teacher and master, Matt. 23:8 ff.; the authority of the king, since he reigns forever in the house of Jacob, Luke 1:32 ff.; and the priestly office, since he is a priest forever after the order of Melchizedek, Ps. 110:4.[19]

What Luther wanted every Christian to know is that we have the same three offices: a prophetical office of proclamation, a sacerdotal office of service, and a royal office of kingdom authority. This had been hinted at already back in the fourth century by John Chrysostom in his preaching on Christian baptism:

> We have now not one of these dignities, but all three preeminently. For we are both to enjoy a kingdom and are made priests by offering our bodies for a sacrifice, (for, saith he, "present your members a living sacrifice unto God") and withal we are constituted prophets too: for what things "eye hath not seen, nor ear heard," (1 Cor. ii.9) these have been revealed unto us. And in another way too we become kings: if we have the mind to get dominion over our unruly thoughts, for that such an one is a king and more than he who weareth the diadem.... So also art thou thyself made king and priest and prophet in the Laver; a king, having

[19]Andreas Osiander, quoted in Wolfhart Pannenberg, *Jesus—God and Man* (London: SCM, 1968), 213.

dashed to earth all the deeds of wickedness and slain thy sins; a priest, in that thou offerest thyself to God, having sacrificed thy body and being thyself slain also, "for if we died with Him," saith he, "we shall also live with Him;" (2 Tim. ii. 11) a prophet, knowing what shall be, and being inspired of God, and sealed.[20]

It was left to the Protestant Reformers to explore the implications of prophethood, priesthood, and kingship for practical Christianity.

John Calvin gave this threefold office a prominent place in his theological system, the famous *Institutes of the Christian Religion*. As prophet, Calvin said, the Son serves as "herald and witness of the Father's grace."[21] As the ruler of a spiritual kingdom, he preserves his church to the very end. Thus "we may patiently pass through this life with its misery, hunger, cold, contempt, reproaches, and other troubles—content with this one thing: that our King will never leave us destitute, but will provide for our needs until, our warfare ended, we are called to triumph."[22] As holy priest—the "pure and stainless Mediator"—Jesus reconciles us to God, making satisfaction for our sins through the sacrifice of his death. He also serves as our "everlasting intercessor," which gives us peace of conscience and confidence in the power of prayer.[23] Calvin then expanded each of these offices by showing how Jesus continues to exercise them through the church. To cite one example, the Christ received his prophetic anointing, "not only for himself that he might carry out the office of teaching, but for his whole body that

[20]John Chrysostom, *Homilies on the Epistles of Paul to the Corinthians*, Nicene and Post-Nicene Fathers, First Series, trans. Talbot W. Chambers, ed. Philip Schaff (1889; repr., Peabody, MA: Hendrickson, 1995), 12:290, 293.

[21]John Calvin, *Institutes of the Christian Religion*, Library of Christian Classics, ed. John T. McNeill, trans. Ford Lewis Battles, 2 vols. (Philadelphia: Westminster, 1960), 2.15.2.

[22]Ibid., 2.15.4.

[23]Ibid., 2.15.6.

the power of the Spirit might be present in the continuing preaching of the gospel."[24]

As the Reformation progressed, the threefold office became part of every Christian's confession. The *Heidelberg Catechism*, written by Zacharias Ursinus and Caspar Olevianus, defines the title "Christ" according to his Father-ordained, Spirit-anointed, threefold office as "chief Prophet and Teacher," "only High Priest," and "eternal King." Then the catechism explains why the catechumen is called a Christian: "Because by faith I am a member of Christ, and thus a partaker of His anointing, in order that I also may a confess His name, may present myself a living sacrifice of thanksgiving to Him, and may with a free conscience fight against sin and the devil in this life, and hereafter, in eternity, rule with Him over all creatures."[25] In this way, the threefold office defines every Christian's calling. On the basis of our baptism, in which we are anointed by the Holy Spirit, we become prophets, priests, and kings. Thus to belong to Christ is not only to share in the benefits of his threefold office but also to exercise its prophetical, sacerdotal, and regal ministry.[26]

In developing this doctrine, the Protestant Reformers were drinking deeply from the well of Holy Scripture. By virtue of the day of Pentecost—when the Father and the Son anointed the church with the Spirit (Acts 2:33)—all God's children (his daughters as well as his sons) have been given the prophetic ministry of proclaiming

[24]Ibid., 2.15.2.

[25]The Heidelberg Catechism (1563), in Thomas F. Torrance, *The School of Faith: The Catechisms of the Reformed Church* (London: James Clarke, 1959), 74 (Q & A 31, 32).

[26]Zacharias Ursinus, *Commentary on the Heidelberg Catechism*, trans. G. W. Williard (1852; repr., Phillipsburg, NJ: P&R, n.d.), 178. See also Francis Turretin, *Institutes of Elenctic Theology*, trans. George Musgrave Giger, ed. James T. Dennison Jr., 3 vols. (Phillipsburg, NJ: P&R, 1994), 2:375-499. More recently, the Roman Catholic Church has developed a doctrine of the priesthood, prophethood, and kingship of all believers. See *Catechism of the Catholic Church*, 2nd ed. (Vatican City: Libreria Editrice Vaticana, 1997), para. 436; cf. para. 871-73.

God's Word (Acts 2:16-18; cf. Num 11:29; Is 59:21; Joel 2:28-29). We speak God's Word to one another, letting it dwell in us richly as we teach and admonish one another with all wisdom (Col 3:16). We also speak God's Word to the world, fulfilling our Great Commission to go to every nation and make disciples by teaching people the commands of Christ (Mt 28:18-20; cf. Acts 8:4; 1 Pet 3:15).

We are not only prophets, however, but also kings and priests. Indeed, as we proclaim God's grace we are "a royal priesthood" (1 Pet 2:9), a veritable kingdom of priests (Rev 1:6; cf. Ex 19:6; Is 61:6; Rev 5:10). The New Testament often uses temple language (e.g., 1 Cor 6:19-20) or metaphors drawn from temple worship (e.g., Phil 2:17; 2 Tim 4:6) to describe our "priestly service" to God (Rom 15:16), in which we offer our very "bodies as a living sacrifice, holy and acceptable to God" (Rom 12:1; cf. Heb 13:15-16). Furthermore, the New Testament promises to believers the royal prerogatives of judging the world (1 Cor 6:2), inheriting the kingdom (Mt 25:34), sitting with Christ on his heavenly throne (Eph 2:6-7; Rev 3:21), and reigning with him forever (Rev 22:5; cf. 2 Tim 2:10-12). We are all priests and kings as well as prophets.

Thus the threefold office that was promised in the Old Testament and fulfilled in Jesus Christ is exercised now through the people of God, by the power of the Holy Spirit, for the sake of the world. Every member of the body of Christ has a prophetic calling to share God's Word, a priestly calling to intercede for others, and a kingly calling to exercise God's authority in the world.

FROM HUMILITY TO NOBILITY

The most priest-like character in *The Lord of the Rings* is Frodo Baggins, but not Frodo alone: in their deep bonds of friendship, Frodo, Sam, and the other hobbits provide us with images of Christian priesthood.

Hobbits are rather ordinary—more ordinary, in fact, than the men of Middle-earth, many of whom descend from Númenor, the island of the ancient kings. Hobbits remind us of the sturdy Englishmen who survived the Blitz and won two World Wars. Indeed, they remind us of Tolkien himself, who enjoyed long walks, second breakfasts, and the smell of fine tobacco. What other novel has a prologue that includes an excursus "Concerning Pipe-weed"?[27] "I am in fact a *Hobbit*," Tolkien confided to one of his many correspondents,

> (in all but size). I like gardens, trees and unmechanized farm-lands; I smoke a pipe, and like good plain food (unrefrigerated), but detest French cooking; I like, and even dare to wear in these dull days, ornamental waistcoats. I am fond of mushrooms (out of a field); have a very simple sense of humour (which even my appreciative critics find tiresome); I go to bed late and get up late (when possible).[28]

Because they are so rustic, not to mention diminutive, hobbits are easily overlooked. Before their adventures begin, we are told that "the world being after all full of strange creatures beyond count, these little people seemed of very little importance."[29] At various points in the novel hobbits are variously described as "Halflings" or "the little folk."[30] Frodo calls them "the Little People" when he writes his memoirs.[31]

Because of their small stature and seeming insignificance, the hobbits have humble expectations for whatever service they may be able to offer. As Frodo draws near to Mordor, with all its

[27]*FR*, 7-9.
[28]Tolkien, *Letters*, 288-89 (no. 213).
[29]*FR*, 2.
[30]*FR*, 347.
[31]*RK*, 1004.

terrors, he considers how unlikely it is that someone like him could ever accomplish his quest: "And here he was a little Halfling from the Shire, a simple hobbit of the quiet countryside, expected to find a way where the great ones could not go, or dared not go."[32] But Frodo had felt this way from the beginning, when he first learned that he would have to bear the Ring. "I am not made for perilous quests," he told Gandalf back at Bag End. "I feel very small, and very uprooted, and well—desperate. The Enemy is so strong and terrible."[33]

The other hobbits feel the same way. When Pippin offers his sword to Lord Denethor, the Steward of Gondor, he says, "Little service, no doubt, will so great a lord of Men think to find in a hobbit, a Halfling from the northern Shire; yet such as it is, I will offer it, in payment of my debt."[34] Minas Tirith is under siege, and soon the fighting is close at hand; knowing that he is hardly a soldier, Pippin compares himself to a pawn "on the wrong chessboard."[35]

Yet for all their apparent weakness, the hobbits are faithful in their service and prove to have surprising strength. When Gandalf sees that Frodo will survive the deep wound of a Morgul blade, he says, "You have some strength in you, my dear hobbit!"[36] Merry and Pippin both acquit themselves well in battle; Merry even strikes the Lord of the Nazgûl.[37] With similar fortitude, Samwise Gamgee singlehandedly attacks a large company of orcs in the Tower of Cirith Ungol. Hobbits can take a blow and, if necessary, can also deliver one.

[32]*TT*, 630.
[33]*FR*, 60-61.
[34]*RK*, 739.
[35]*RK*, 750.
[36]*FR*, 213.
[37]*RK*, 824.

In offering such brave service, the hobbits in *The Lord of the Rings* become enlarged, moving from weakness to greatness. Tolkien saw this as one of the main themes of his story, which he described in one of his letters as "primarily a study of the ennoblement (or sanctification) of the humble."[38] Elsewhere, in talking about how much he loved his hobbits, the author said, "Nothing moves my heart (beyond all the passions and heartbreaks of the world) so much as 'ennoblement.'"[39] This theme is indicated partly by the dignified titles that the hobbits are given toward the end of the story. When Frodo and Sam fight against the hideous spider Shelob, they are identified as "Frodo, hobbit of the Shire" and "Samwise the hobbit, Hamfast's son."[40] When Pippin swears "fealty and service to Gondor," he does so in the name of "Peregrin son of Paladin of the Shire of the Halflings."[41] Similarly, when Merry pledges his allegiance to Rohan, he lays "the sword of Meriadoc of the Shire" on the lap of King Théoden.[42] We have known the names of these unlikely heroes from the opening pages, so none of this is new information. But the use of formal epithets expresses both the humility of their origins and the nobility of their service.

After completing their great quest, Frodo and Sam are lauded "with great praise" and robed in clean linen.[43] Nor does Gandalf hesitate to tell people that Merry and Pippin are "valiant."[44] And when Aragorn becomes king, he declares that all four hobbits in the Fellowship of the Ring "shall ride in honour and arrayed as

[38]Tolkien, *Letters*, 232 (no. 181).
[39]Ibid., 237 (no. 181).
[40]*TT*, 705, 713.
[41]*RK*, 740.
[42]*RK*, 756.
[43]*RK*, 933.
[44]*RK*, 733, 850.

princes of the land."[45] In short, by doing their duty, the lowly
have become lordly. Such honor is only their due, for as much as
anyone else, the hobbits are the heroes who save Middle-earth.
As Peter Kreeft points out, "In *The Lord of the Rings* the Hobbits
appear at first to be only comic contrast to the larger and more
heroic Men and Elves; yet almost all the greatest deeds are
achieved by Hobbits."[46] Kreeft's conclusion finds support in
Tolkien's *Silmarillion*, where we read that although Halflings
"had been held of small account by Elves and by Men, and neither
Sauron nor any of the Wise save Mithrandir had in all their
counsels given thought to them," nevertheless in the hour of
need "help came from the hands of the weak when the Wise
faltered. For, as many songs have since sung, it was the Peri-
annath, the Little People, dwellers in hillsides and meadows, that
brought them deliverance."[47] One is reminded of 1 Corinthians
1:27: "God chose what is weak in the world to shame the strong."

The nobility of the hobbits is perhaps most clearly apparent
when they return to the Shire to scour away the evil stain of Sa-
ruman. Gandalf knows that they no longer need his aid but will be
more than able to handle whatever they must face when they get
back home. Indeed, settling the Shire's affairs is what they have
been "trained for." "You are grown up now," the wizard tells them.
"Grown indeed very high; among the great you are, and I have no
longer any fear at all for any of you."[48] Even Saruman grudgingly
admits that Frodo has "grown very much."[49]

[45]*RK*, 952.

[46]Peter J. Kreeft, *The Philosophy of Tolkien: The Worldview Behind "The Lord of the Rings"* (San
Francisco: Ignatius, 2005), 212.

[47]J. R. R. Tolkien, *The Silmarillion*, 2nd ed., ed. Christopher Tolkien (Boston: Houghton
Mifflin, 2001), 303.

[48]*RK*, 974; cf. 1072.

[49]*RK*, 996.

The pleasing juxtaposition of humility and nobility should characterize whatever priestly service the church offers to the world. Apart from Jesus Christ, we are so weak that we can do nothing—literally, nothing (Jn 15:5). Yet every one of his followers carries his name and his calling. As we offer God our humble service, we are ennobled. The priesthood of all believers thus dignifies the daily life and ministry of ordinary Christians.

BEARING A BURDEN

The biblical priesthood was a ministry of sacrifice and prayer, instruction and benediction. From Aaron to Ezra, the Old Testament priests entered God's holy presence to make atonement and to offer intercession. Then they re-emerged to teach the law and to bless the people of God.

Jesus, too, was a priest, as was prophesied. The Old Testament anticipated "a faithful priest" (1 Sam 2:35), who would not only intercede for transgressors but actually bear their transgressions (Is 53:1-12). Christ's priestly ministry came into sharpest focus with his passion. The prayer that Jesus offered on the eve of his crucifixion (Jn 17) is rightly styled the High Priestly Prayer, for in it the greatest of all priests made intercession for his people. Then he offered priestly atonement, not by bringing a sacrifice, but by becoming one: "Christ loved us and gave himself up for us, a fragrant offering and sacrifice to God" (Eph 5:2). Jesus suffered greatly in making this sacrifice, for while he was dying on the tree of Calvary, people scorned the efficacy of his priestly ministry. "He saved others," they sneered; "let him save himself, if he is the Christ of God, his Chosen One!" (Lk 23:35). Yet at that very moment Jesus was interceding for his enemies (Lk 23:34) and offering his body and his blood as a sacrifice for their sins.

Apparently, it takes a whole book to explain this one humiliating act of atonement, for virtually the entirety of Hebrews is an argument for and celebration of the "great high priest who has passed through the heavens" (Heb 4:14). By the appointment and designation of his Father (Heb 5:5, 10), Jesus became "a merciful and faithful high priest in the service of God, to make propitiation for the sins of the people" (Heb 2:17). Then, having made this singular sacrifice of himself once and "for all time" (Heb 10:12), Jesus concluded his earthly ministry to his disciples by performing a priestly act of benediction: "lifting up his hands he blessed them" (Lk 24:50). By virtue of his "indestructible life" (Heb 7:16), his priestly ministry continues right up to the present moment: Jesus "always lives to make intercession" for those who draw near to God through him (Heb 7:25; cf. 1 Jn 2:1). Briefly stated, this is the biblical pattern of the priesthood in the life and ministry of Jesus Christ.

Frodo Baggins provides an image of the priesthood primarily by bearing the burden of the One Ring of Power. He claims this burden at the Council of Elrond, where he steps forward and says, "I will take the Ring, though I do not know the way."[50] The hobbit more or less knows what he is getting into, because when Gandalf first explains how perilous the Ring is, and why Frodo needs to leave home to deal with its danger, Frodo says, "But this would mean exile, a flight from danger into danger, drawing it after me. And I suppose I must go alone, if I am to do that and save the Shire."[51] As Frodo sits and listens to the long debates at the Council of Elrond, an "overwhelming longing to rest and remain at peace by Bilbo's side in Rivendell filled all his heart."[52] Yet the hobbit is willing to make the sacrifice and carry the Ring—which

[50]*FR*, 264.
[51]*FR*, 61.
[52]*FR*, 263.

even Elrond considers a burden "so heavy that none could lay it on another"[53]—all the way to Mordor.

Tolkien repeatedly uses the word *burden* to describe the Ring. According to the summary in *The Silmarillion*, "Frodo the Halfling, it is said, at the bidding of Mithrandir took on himself the burden."[54] Celeborn, the Lord of Lorien, describes Frodo as "that one of the little folk who bears the burden."[55] When the Fellowship debates what direction they should take on the green lawn of Parth Galen, Aragorn says of Frodo, "He is the Bearer, and the fate of the Burden is on him."[56]

The closer that Frodo draws to Mordor, the heavier his burden becomes: "In fact with every step towards the gates of Mordor Frodo felt the Ring on its chain about his neck grow more burdensome. He was now beginning to feel it as an actual weight dragging him earthwards."[57] As the hobbits pass the Cross-roads and draw close to the deadly stairs of Cirith Ungol, Frodo's head is bowed: "his burden was dragging him down again."[58] The hobbit is tempted severely to run straight into the arms of his enemies. And when "at last with an effort he turned back, he felt the Ring resisting him, dragging at the chain about his neck."[59] "It's heavy on me, Sam lad, very heavy," the hobbit says. "I wonder how far I can carry it?"[60]

The Ring is a burden for Sam, too, during the hours when his master is unconscious and he sees no choice but to take the Ring. When he first "bent his own neck and put the chain upon it," at

[53]*FR*, 264.
[54]*Sil*, 303.
[55]*FR*, 347.
[56]*FR*, 394.
[57]*TT*, 616.
[58]*TT*, 688.
[59]*TT*, 689.
[60]*TT*, 690.

once "his head was bowed to the ground with the weight of the Ring, as if a great stone had been strung on him."[61] Somehow Sam manages to carry this burden to the edge of Mordor, where he halts at the top of a mountain pass before descending into the depths. There, "without any clear purpose," he takes out the Ring and puts it on again: "Immediately he felt the great burden of its weight, and felt afresh, but now more strong and urgent than ever, the malice of the Eye of Mordor."[62] Soon the hobbit comes within sight of Mount Doom and is "aware of a change in his burden."[63] The weight grows heavier still, and Sam can sense that it would be "nothing but a drag and a burden every step."[64]

Later, when Frodo regains consciousness and wants the Ring back, Sam resists: "It's round my neck now, and a terrible burden it is, too."[65] Although Sam returns it, he feels "reluctant to give up the Ring and burden his master with it again."[66] "You'll find the Ring very dangerous now," he warns Frodo, "and very hard to bear."[67] This is hardly news to Frodo, of course. "It is such a weight to carry," he says, "such a weight.... It is my burden, and no one else can bear it."[68]

Although Sam cannot bear the Ring again, he can bear the Ring-bearer. This is his priestly service to Frodo, which is foreshadowed throughout the trilogy. When the hobbits first set out from Bag End, Frodo rightly suspects that Sam has chosen to carry the heaviest pack.[69] At various points along their journey, we

[61] *TT*, 716.
[62] *RK*, 878.
[63] *RK*, 880.
[64] *RK*, 881.
[65] *RK*, 890.
[66] *RK*, 890.
[67] *RK*, 891.
[68] *RK*, 926.
[69] *FR*, 69.

see Sam "supporting and guiding his stumbling master,"[70] or taking his hand to lead him through the mountains and the dark.[71] "Bless you! I'd carry you on my back, if I could," he tells Frodo.[72] Later Sam vows to "carry Mr. Frodo up myself, if it breaks my back and heart"[73]—which is precisely what he does in the event. When his master loses almost all hope and is too weak to travel even one more step, Sam says, "Come, Mr. Frodo! I can't carry it for you, but I can carry you and it as well. So up you get! Come on, Mr. Frodo dear! Sam will give you a ride. Just tell him where to go, and he'll go."[74]

What enables these Ring-bearers to fulfill their hopeless quest is the Christian virtue of perseverance. Having once taken up their burden, they are determined to carry it all the way to the end. When Frodo first sets out from the Shire, he tries to discourage his faithful gardener from going with him. But Sam says, "I have something to do before the end, and it lies ahead, not in the Shire. I must see it through, sir, if you understand me"[75]—words that come back to the steadfast hobbit when Frodo is taken prisoner and Sam doesn't know what to do next.[76] For his part, Frodo is equally determined. As the hobbits plan their escape from the Tower of Cirith Ungol, he says, "I wish it had never, never, been found. But don't mind me, Sam. I must carry the burden to the end."[77]

With such resolve, the hobbits persevere in bearing what Frodo afterward would call "a long burden."[78] Like the heroes in the great

[70]*TT*, 689.
[71]*RK*, 907, 929.
[72]*RK*, 897.
[73]*RK*, 918.
[74]*RK*, 919.
[75]*FR*, 85.
[76]*TT*, 714.
[77]*RK*, 891.
[78]*RK*, 967.

stories they have read, they have "lots of chances of turning back," only they don't.[79] They persevere even though they are afraid, as Frodo admits to Boromir.[80] They persevere in the face of temptation, especially Frodo's constant temptation simply to give the Ring back to Sauron's Black Riders.[81] They persevere through extreme fatigue. At the deadly gate of Morannon, Frodo is "filthy, haggard, and pinched with weariness." But he is steadfast in his commitment: "I purpose to enter Mordor, and I know no other way. Therefore I shall go this way."[82] The hobbits persevere when there seems to be no hope of success. "I never hoped to get across," Frodo admits to Sam. "I can't see any hope of it now. But I've still got to do the best I can."[83]

The hobbits also persevere in the face of certain death. When Sam realizes that they will not have enough food to return from Mount Doom, he thinks to himself, "So that was the job I felt I had to do when I started: to help Mr. Frodo to the last step and then die with him? Well, if that is the job then I must do it."[84] This is the moment when "Sam's plain hobbit-face grew stern, almost grim, as the will hardened in him, and he felt through all his limbs a thrill, as if he was turning into some creature of stone and steel that neither despair nor weariness nor endless barren miles could subdue."[85] The humble gardener is ready to fulfill the promise he made to himself back in Lothlórien: "I'll go home by the long road with Mr. Frodo, or not at all."[86]

[79] *TT*, 696.
[80] *FR*, 388.
[81] E.g., *FR*, 392.
[82] *TT*, 623.
[83] *RK*, 903; cf. *TT*, 692.
[84] *RK*, 913.
[85] *RK*, 913.
[86] *FR*, 354.

SACRIFICE UNTO DEATH

Make no mistake: by persevering in carrying the Ring to Mount Doom, Frodo and Sam are bearing a burden unto death, which is a freely offered service of priestly sacrifice. Hobbits have always been known for their generosity. Consider their extraordinary custom of giving rather than receiving presents on their birthdays.[87] But in this case, Frodo is prepared to lay down his life for his friends, sacrificing himself for the kingdom. Leon Podles writes:

> In *The Lord of the Rings*, Frodo becomes the true hero, but his heroism is not one of military valor. He is like a sacrificial priest, and one who must become part of the sacrifice. He crosses the dead lands, which are like the poisoned battle-fields of the First World War. He disguises himself and slowly strips himself of all possessions—his sword, even the food that he would need to return.[88]

Craig Bernthal goes so far as to describe Frodo's journey as a Via Dolorosa: Amon Hen is the hobbit's Gethsemane, where he wrestles with his calling and chooses to surrender; he sets his face toward Mount Doom, just as Christ set his face toward the Hill of Calvary; at Cirith Ungol he is stripped and scourged; in Mordor he gives up his sword; on his way up to die, Samwise Gamgee becomes his Simon of Cyrene; and so forth.[89] Each of these episodes parallels an experience of Jesus on his way to the cross.

In the end Frodo and Sam are rescued by eagles, so they do not die after all; they survive. Still, they go to Mount Doom with no

[87] *FR*, 26.

[88] Leon J. Podles, "The Heroes of Middle-Earth: J. R. R. Tolkien & the Marks of Christian Heroism," *Touchstone*, January/February 2002, 31.

[89] Craig Bernthal, *Tolkien's Sacramental Vision: Discerning the Holy in Middle Earth* (Oxford: Second Spring, 2014), 259. See also Verlyn Flieger, *Green Suns and Faerie: Essays on Tolkien* (Kent, OH: Kent State University Press, 2012), 228-29.

expectation that they will return. Indeed, Frodo deliberately gives himself over to death. "I don't know how long we shall take to—to finish," he says to Sam:

We were miserably delayed in the hills. But Samwise Gamgee, my dear hobbit—indeed, Sam my dearest hobbit, friend of friends—I do not think we need give thought to what comes after that. To *do the job* as you put it—what hope is there that we ever shall? And if we do, who knows what will come of that? If the One goes into the Fire, and we are at hand? I ask you, Sam, are we ever likely to need bread again? I think not. If we can nurse our limbs to bring us to Mount Doom, that is all we can do. More than I can, I begin to feel.[90]

Peter Kreeft has observed that *The Lord of the Rings* reverses our expectations by taking us on a quest, not to gain something, but to give it up.[91] Frodo and Sam go to Mount Doom in order to throw away something that they both were tempted to keep, or else to use for their own purposes. This costly quest is deeply Christian:

Tolkien's heroes do not know, believe, mention, wonder about, or allegorize Christian doctrine. But they exemplify exactly what life would be like if the Christian claims are true, especially its central paradox about immortality through death and resurrection of the self, self-realization through self-sacrifice. Frodo gives himself up for the Shire, and for all Middle-earth, by accepting the burden of the Ring and not lusting after it.[92]

One problem with this interpretation, of course, is that when Frodo finally reaches Mount Doom, he gives in to temptation by

[90]*TT*, 610.
[91]Kreeft, *Philosophy of Tolkien*, 216.
[92]Ibid., 99.

refusing to destroy the Ring but claiming it for himself instead: "I have come. But I do not choose now to do what I came to do. I will not do this deed. The Ring is mine!"[93] So Frodo is not the perfect Savior. We might even say that he fails in his quest. He does not, in fact, sacrifice himself for the redemption of Middle-earth. The Ring is only destroyed because Gollum bites off his ring finger and falls into the fire.[94] Stephen Morillo is among the critics who thus claim that Gollum is the one who saves "not only the world, but Frodo himself from his unsavior-like moment of weakness."[95]

But we need to make sure that we give Frodo the credit that he deserves. Against every expectation he perseveres in his quest, makes it to Mount Doom, and puts himself in a position to succeed. Nor should we forget for a moment that Gollum is only there at the end because Frodo pitied him and rescued him.

At the beginning of the novel, when Gandalf first explains the power and danger of the Ring, Frodo has no pity for Gollum at all.[96] Yet he learns to have compassion on the poor creature, and more than once he freely spares his life. When Sam captures Gollum in Emyn Muil, Frodo hears again the words that Gandalf spoke when they were back at Bag End and Frodo said it was a pity that Bilbo did not "stab the vile creature" when he had the chance: "I do not feel any pity for Gollum. He deserves death."[97] "Pity?" Gandalf replied on that occasion. "It was Pity that stayed his hand. Pity, and Mercy: not to strike without need."[98] Later, when Faramir threatens to shoot the wretch by the forbidden pool at Henneth Annun,

[93]*RK*, 924.

[94]*RK*, 925.

[95]Stephen Morillo, "The Entwives: Investigating the Spiritual Core of *The Lord of the Rings*," in *The Ring and the Cross: Christianity and "The Lord of the Rings,"* ed. Paul E. Kerry (Teaneck, NJ: Fairleigh Dickinson University Press, 2013), 112-13.

[96]*FR*, 58.

[97]*TT*, 601.

[98]*TT*, 601; cf. *FR*, 58.

Frodo answers for Gollum's life.[99] Since the hobbit's forbearance is undeserved, *mercy* is just the word for it. Presumably Samwise Gamgee would have called Frodo's act of kindness "folly,"[100] but the word that Tolkien uses for it most frequently is *pity*.[101] By exercising this distinctively Christian (and perhaps priestly) virtue—there is, after all, no pity in paganism—Frodo makes it possible for Gollum to fulfill his strange purpose at the Cracks of Doom.

There are several ways to resolve the strange paradox of Frodo's simultaneous defeat and victory. Ralph Wood compares it to the mystery of the cross, where an apparent defeat proves to be a stunning victory. He writes:

> This is surely the most surprising and anti-climactic moment in the novel. After his long twilight struggle to carry the Ring back to the Cracks of Doom, Frodo fails at the very last—not because of his own weakness of will but because the Ring finally overwhelms him. Thus does the Quest end not in jubilant victory but disappointing defeat, as Tolkien deflates all his readers' hopes for a conventional heroic ending. Yet he accomplishes something far more important—the awful juxtaposition of radical good and radical evil. Tolkien demonstrates that the mightiest evil can summon forth the very highest good in a character such as Frodo, even as it defeats him. So did Gethsemane end in Golgotha, as Jesus died with a shout that is hardly a cry of conquest. The cross is the great Christian eucatastrophe because it is sheer defeat overcome by sheer victory.[102]

[99] *RK*, 668-78.
[100] See *TT*, 625-26.
[101] E.g., *TT*, 601, 671.
[102] Ralph C. Wood, *The Gospel According to Tolkien: Visions of the Kingdom in Middle-Earth* (Louisville, KY: Westminster John Knox, 2003), 73.

Another way to resolve the paradox of Mount Doom is to regard the salvation of Middle-earth as a kind of divine grace. Frodo cannot save the kingdom by himself any more than Gollum can, or even Gandalf. "It can only be God himself," writes Stratford Caldecott, "working through the love and freedom of his creatures." The destruction of the Ring, then, is both "a triumph of providence over fate" and "a triumph of mercy."[103]

Tolkien proposed a similar resolution, believing as he did in "the Writer of the Story."[104] He wrote in one of his letters:

> I do not think that Frodo's was a *moral* failure. At the last moment the pressure of the Ring would reach its maximum—impossible, I should have said, for any one to resist, certainly after long possession, months of increasing torment, and when starved and exhausted. Frodo had done what he could and spent himself completely (as an instrument of Providence) and had produced a situation in which the object of his quest could be achieved. His humility (with which he began) and his sufferings were justly rewarded by the highest honour; and his exercise of patience and mercy towards Gollum gained him Mercy: his failure was redressed.[105]

To give Frodo the credit that he deserves, and to see the full extent of his willing sacrifice, we also need to follow his journey beyond Mount Doom to the Grey Havens, where he sets off across the High Sea to distant shores, where he "smelled a sweet fragrance on the air and heard the sound of singing that came over

[103]Stratford Caldecott, *The Power of the Ring: The Spiritual Vision Behind "The Lord of the Rings" and "The Hobbit,"* 2nd ed. (New York: Crossroad, 2012), 58.

[104]Tolkien, *Letters*, 253 (no. 192).

[105]Ibid., 326 (no. 246). See also ibid., 251-52 (no. 191) and 233-34 (no. 161), where Tolkien describes the climactic scene as a "sacrificial situation" that was created by Frodo's forgiveness and in which "he was saved himself, and relieved of his burden."

the water."[106] The hobbit has carried such a heavy burden for so long and been so terribly wounded by the Black Riders that in the end he must leave Middle-earth. "I have been too deeply hurt," Frodo explains. "I tried to save the Shire, and it has been saved, but not for me. It must often be so, Sam, when things are in danger: some one has to give them up, lose them; so that others may keep them."[107] In the end, what Frodo has to give up is his beloved Shire. In a real sense, bearing the burden of the Ring costs him his life.

If there is death for Frodo, there is also a kind of resurrection. We see this more clearly in Gandalf and Aragorn, but it is present enough in Frodo for us to see him as another messianic figure. His rescue at Mount Doom is a life-after-death experience, but so is his rescue at Cirith Ungol, when at first Sam leaves him for dead. Before leaving his master's side, Sam is given what we might perhaps describe as a beatific vision of a glorified hobbit: "For a moment he lifted up the Phial and looked down at his master, and the light burned gently now with the soft radiance of the evening-star in summer, and in that light Frodo's face was fair of hue again, pale but beautiful with an elvish beauty, as of one who has long passed the shadows."[108]

SHARING ONE ANOTHER'S BURDENS

Sam's last words to Frodo at Cirith Ungol are "Good-bye, master, my dear! Forgive your Sam. He'll come back to this spot when the job's done—if he manages it. And then he'll not leave you again. Rest you quiet till I come."[109] This touching scene illustrates well

[106] *RK*, 1007.
[107] *RK*, 1006.
[108] *TT*, 716; cf. 638.
[109] *TT*, 716.

the extraordinary affection that Sam and Frodo share. Leon Podles goes so far as to identify male friendship as "the emotional center" of *The Lord of the Rings*.[110]

The friendship of these two intrepid hobbits proves crucial to their quest. As Frodo and Sam make their desperate ascent up the Stairs of Cirith Ungol, they whimsically imagine some future day when a father will sit beside the fire and read the stories of their adventures to his children. Frodo imagines the children clamoring for more tales about Samwise the stouthearted, with one of them saying, "Frodo wouldn't have got far without Sam, would he, dad?"[111]

No, Frodo wouldn't have got far without Sam (or without Merry and Pippin, for that matter). According to Caldecott, Tolkien "shows us that we begin to become heroes simply by being friends, by being loyal to each other through the trials that afflict us and holding tight to the things and people that are worthy of love."[112] The strong interdependency of the indomitable hobbits in their mutual friendships makes them an ideal illustration of the priesthood of all believers. We were never meant to bear our burdens alone, but always to share them in community with other Christians.

Frodo's initial intention to travel alone is one of the conflicts that drives Tolkien's plot, especially in the first volume of the trilogy. Gandalf advises against a solo journey. "I don't think you need go alone," he says to Frodo. "Not if you know of anyone you can trust, and who would be willing to go by your side—and that you would be willing to take into unknown perils."[113] The elf-lord Gildor gives similar advice when he chances on Frodo in the Shire: "Do not go alone. Take such friends as are trusty and willing."[114] This counsel

[110]Podles, "Heroes of Middle-Earth," 30.
[111]*TT*, 697.
[112]Caldecott, *Power of the Ring*, 169.
[113]*FR*, 61.
[114]*FR*, 83.

notwithstanding, Frodo fully intends to leave his friends behind when he leaves Bag End and again when he departs from the Shire. He is unwilling to take them "into exile, where hunger and weariness may have no cure," even if they are willing to join him. "I don't think I ought even to take Sam," he says to himself.[115]

The other hobbits find Frodo's intention utterly laughable. For them, it is unthinkable that a friend would make a hard journey or attempt a dangerous task alone. Sam offers his total commitment to Frodo: "If you don't come back, sir, then I shan't, that's certain. . . . *Don't you leave him!* they said to me. *Leave him!* I said. *I never mean to. I am going with him, if he climbs to the Moon; and if any of those Black Riders try to stop him, they'll have Sam Gamgee to reckon with,* I said."[116] This vow comes back to Sam at the doorstep of Mordor, when Frodo is prepared to walk through its gates alone if he has to. Sam "had stuck to his master all the way; that was what he had chiefly come for, and he would still stick to him. His master would not go to Mordor alone. Sam would go with him."[117]

Merry and Pippin are equally firm in their resolve. "You do not understand!" Pippin tells Frodo. "You must go—and therefore we must, too. Merry and I are coming with you. Sam is an excellent fellow, and would jump down a dragon's throat to save you, if he did not trip over his own feet; but you will need more than one companion in your dangerous adventure." Frodo responds by telling his "dear and most beloved hobbits" that he cannot allow them to join him, that they simply do not understand what it would mean to fly with him "from deadly peril into deadly peril." "Of course we understand," Merry says firmly. "That is why we have decided to come."[118]

[115] *FR*, 84-85.
[116] *FR*, 85.
[117] *TT*, 624.
[118] *FR*, 102.

The question of companions comes up again at Rivendell, in the Council of Elrond, which Sam attends without invitation and then interrupts to insist that he will go with Frodo.[119] The way that Frodo signals his acceptance is telling. "I will go with Sam," he says—almost as if he were the traveling companion.[120] Their partnership is mutual.

When the other hobbits learn that they are to be left behind, they are indignant. "We hobbits ought to stick together, and we will," says Pippin. "I shall go, unless they chain me up. There must be someone with intelligence in the party."[121] Not long afterward, Pippin seizes the chance to make his case directly to Elrond: "We don't want to be left behind. We want to go with Frodo."[122] The two young hobbits renew this commitment later on, when the Fellowship debates which way to go from the fair lawn of Parth Galen. Merry says, "We can't leave Frodo! Pippin and I always intended to go wherever he went, and we still do."[123] Similarly, Pippin says, "But the dear silly old hobbit, he ought to know that he hasn't got to ask. He ought to know that if we can't stop him, we shan't leave him."[124] In the end, Gandalf persuades Elrond—against his better judgment—"to trust rather to their friendship than to great wisdom" and to appoint all four hobbits to the Fellowship of the Ring.[125]

This decision proves crucial to the success of Frodo's quest and helps secure the freedom of Middle-earth. Many times the hobbits rescue one another from danger or else give each other the courage to persevere. The first instance occurs right after the hobbits leave

[119] *FR*, 264.
[120] *FR*, 268.
[121] *FR*, 265.
[122] *FR*, 269.
[123] *FR*, 393.
[124] *FR*, 394.
[125] *FR*, 269.

the home of Tom Bombadil and fall under the deadly power of the Barrow-wight. Frodo has wild thoughts of escape, "but the courage that had been awakened in him was now too strong: he could not leave his friends so easily."[126] The hobbit resists the temptation to flee and summons all his strength to hack off the dreadful hand groping toward his companions. But perhaps the clearest example is the way that Sam literally carries Frodo up Mount Doom. This is no more than Gandalf anticipated. When the wizard receives word that after the breaking of the Fellowship Frodo did not venture to Mordor alone, it comes as a huge relief and a sudden joy. "We think that Sam went with him," Legolas says. "Did he!" says Gandalf, with "a gleam in his eye and a smile on his face. 'Did he indeed? It is news to me, yet it does not surprise me. Good! Very good! You lighten my heart.'"[127] After the Battle of Pelennor Fields, as the wizard tends to Merry's wounds in the Houses of Healing, he thinks back to the long debates at Rivendell and says to Pippin: "[Merry] has well repaid my trust; for if Elrond had not yielded to me, neither of you would have set out; and then far more grievous would the evils of this day have been."[128]

One way to measure the depth of these hobbit friendships is by the way they experience loneliness when they are separated. After Merry and Pippin escape from the orcs, while they are waiting for Treebeard and the other Ents to finish their long Entmoot, the young hobbits suddenly experience "a great longing . . . for the faces and voices of their companions."[129] Later we are told that "amid all their cares and fear the thoughts of their friends turned constantly to Frodo and Sam."[130]

[126] *FR*, 138.
[127] *TT*, 485.
[128] *RK*, 841.
[129] *TT*, 471.
[130] *RK*, 877.

When Merry and Pippin go their separate ways—Merry to Rohan and Pippin to Gondor—they experience the same longing. "I am lonely, to tell you the truth," Pippin confides to a soldier at Minas Tirith. "I left my best friend behind in Rohan, and I have had no one to talk to or jest with."[131] Merry misses Pippin just as much.[132] As the Riders of Rohan muster for their journey to Minas Tirith, he is lonelier than he has ever been in his life. He wonders "where in all this strange world Pippin had got to," when "suddenly like a cold touch on his heart he thought of Frodo and Sam."[133] These feelings return later in the ride, when Merry feels "small, unwanted, and lonely" and imagines Pippin "shut up in the great city of stone, lonely and afraid."[134]

Sam's feelings for Frodo are equally intense. Consider the agony of his decision to leave what he believes to be his master's corpse in Shelob's lair: "He could not go, not yet. He knelt and held Frodo's hand and could not release it. And time went by and still he knelt, holding his master's hand, and in his heart keeping a debate."[135] Sam goes so far as to wonder whether it would be better for them to be dead together than for him to leave his master. Later Pippin will have similar thoughts at the Black Gate as he prepares for battle: "We might die together, Merry and I, and since die we must, why not?"[136]

Although he has no real alternative, Sam quails at the thought of proceeding alone: "What? Me, alone, go to the Crack of Doom and all? . . . Why am I left all alone to make up my mind?"[137] The point is

[131] *RK*, 750.
[132] *RK*, 759.
[133] *RK*, 775.
[134] *RK*, 812.
[135] *TT*, 714.
[136] *RK*, 874; cf. 807.
[137] *TT*, 715.

that hobbits are meant to travel together. When Frodo, Sam, Merry, and Pippin first set off across the Shire, fearful of the mysterious Black Riders, "they went abreast and in step, to keep up their spirits."[138] We get a fuller description of how hobbits walk together in *The Two Towers*, after Merry and Pippin manage to escape from the orcs:

> They turned and walked side by side slowly along the line of the river. Behind them the light grew in the East. As they walked they compared notes, talking lightly in hobbit-fashion of the things that had happened since their capture. No listener would have guessed from their words that they had suffered cruelly, and been in dire peril, going without hope towards torment and death; or that even now, as they knew well, they had little chance of ever finding friend or safety again.[139]

These descriptions of companionship help us understand Sam's dilemma in Shelob's lair. Traveling alone is against his nature. It would also diverge from the story's narrative arc. Hobbits stick together. Soon enough Sam will realize his mistake, when the orcs discover Frodo's body and take him into captivity. His place is always by Frodo's side: "I got it all wrong! I knew I would. Now they've got him, the devils! The filth! Never leave your master, never, never: that was my right rule. And I knew it in my heart. May I be forgiven! Now I've got to get back to him. Somehow, somehow!"[140]

The reunions that the hobbits enjoy after long separation are sweet. "How glad I am to see you again!" Pippin exclaims when Merry comes in from the Battle of Pelennor Fields.[141] Seeing how badly his friend is wounded, he says, "Lean on me, Merry lad!"

[138]*FR*, 75.

[139]*TT*, 448.

[140]*TT*, 724; cf. 718.

[141]*RK*, 840.

Then "he let Merry sink gently down on to the pavement in a patch of sunlight, and then he sat down beside him, laying Merry's head in his lap. He felt his body and limbs gently, and took his friend's hands in his own."[142]

The scenes where Sam cares for Frodo are equally tender. When Sam finds his master in the high tower of Cirith Ungol, he takes him in his arms. Frodo "lay back in Sam's gentle arms, closing his eyes, like a child at rest when night-fears are driven away by some loved voice or hand. Sam felt that he could sit like that in endless happiness; but it was not allowed. It was not enough for him to find his master, he had still to try and save him. He kissed Frodo's forehead."[143] Later, when they draw closer to Mount Doom, Sam kisses Frodo's hand when he is afraid,[144] and tries to comfort his master by wrapping his arms around him.[145] As they make their final approach to the Sammath Naur, the Chambers of Fire, Frodo reaches out for a friend that he can touch and whispers, "Help me, Sam! Help me, Sam! Hold my hand!" And so "Sam took his master's hands and laid them together, palm to palm, and kissed them; and then he held them gently between his own."[146]

In each case, Sam practices a ministry of presence, like the Old Testament priests, who did not have a territory to call their own (Deut 10:9) but were scattered across Israel to live among the other tribes (Num 35:6-8). On occasion, Israel's priests performed their rotation of sacerdotal duties at the temple in Jerusalem. But what prepared them to exercise this priestly ministry was their active participation in the community life of God's people. Even more, we see a ministry of presence in the coming of Christ as God

[142]*RK*, 841.
[143]*RK*, 889.
[144]*RK*, 917.
[145]*RK*, 919; cf. *TT*, 698-99.
[146]*RK*, 921.

incarnate (Jn 1:14) and in his priestly promise to be with us forever (Mt 28:20; Rev 21:3). A priest is someone who stays close beside his friends.

The open tenderness and physical affection that the hobbits show one another may embarrass some contemporary readers. When Peter Jackson tried to portray this in his films, some critics objected to what they perceived as homosexual overtones that were alien to Tolkien's vision. What are we to make of all the caressing of hands[147] and lying in one another's laps that the hobbits do?

In the novel, there is a simple explanation for all the emotional and physical intimacy that Frodo, Sam, and the other hobbits share: they love one another, with true brotherly love—the *philia* that C. S. Lewis so beautifully describes in his book *The Four Loves*.[148] *Love* is just the word that Tolkien uses to describe their feelings for one another. When Sam summons the courage to attack the orcs and attempts to rescue his master at Cirith Ungol, "his love for Frodo rose above all other thoughts, and forgetting his peril he cried aloud: 'I'm coming Mr. Frodo!'"[149] Similarly, in his hour of trial, as Sam wrestles with the temptation to use the Ring, "it was the love of his master that helped most to hold him firm."[150]

The loving friendship of Frodo and Sam triumphs over every evil—even the last enemy, death. After the Ring is destroyed, we see the two hobbits through the eyes of the eagle Gwaihir, the Windlord, who spies "two small dark figures, forlorn, hand in hand upon a little hill, while the world shook under them, and

[147]See also *FR*, 219; *TT*, 610; *RK*, 929.

[148]C. S. Lewis, *The Four Loves* (London: Geoffrey Bles, 1960). For an approach to understanding Frodo that focuses on the virtue of charity, see David Rozema, "*The Lord of the Rings*: Tolkien, Jackson, and 'The Core of the Original,'" *Christian Scholar's Review* 37, no. 4 (Summer 2008): 440-45.

[149]*RK*, 879.

[150]*RK*, 881; cf. *TT*, 638.

gasped, and rivers of fire drew near."[151] The hobbits do not yet have any expectation of rescue, but their friendship is unto death. "I am glad you are here with me," Frodo says. "Here at the end of all things, Sam."[152]

PRACTICAL IMPLICATIONS

As faithful friends, Frodo, Sam, and the other hobbits are models of Christian virtue and exemplars of the priesthood of all believers. They nobly bear one another's burdens, even unto death, and accomplish far more for the kingdom together than they ever could alone.

We too have a priestly calling to the world.[153] Like Christ, we are called to serve and to sacrifice, through a ministry of presence and through prayer. In every leadership situation, there is and ought to be a priestly dimension to our care for others. Thus *The Lord of the Rings* has what Tolkien called "applicability" for everyone. What burden has God called us to carry? Who needs our faithful presence as they walk down a difficult road? And where do we need to exercise greater dependence on other Christians to accomplish the kingdom commitments that we have made to Jesus Christ?

Part of my duty as the president of a Christ-centered college is to practice a ministry of presence. Indeed, few aspects of a college presidency are more important, or more rewarding. There is always something for a president to do on a college campus: host dinners, go to plays and concerts, attend athletic competitions, visit classes and lectures, drop by dormitory events and house parties, show up at retirement receptions, and so on. People expect to see the president,

[151]*RK*, 930.
[152]*RK*, 926.
[153]See Uche Anizor and Hank Voss, *Representing Christ: A Vision for the Priesthood of All Believers* (Downers Grove, IL: IVP Academic, 2016).

and rightly so. The simple presence of the primary leader pronounces the blessing of the entire campus on any activity.

The priestly office is also a ministry of care and concern. Recall that the high priesthood of Jesus is characterized by compassion; he is not unsympathetic to our problems but knows exactly what we need because he has been in our situation before (see Heb 4:15; 5:7). Remember as well that in his earthly ministry Jesus constantly was drawn to people in need—the needier, the better. Thus college presidents fulfill their priestly calling when they promote student welfare, set a high standard for community care, and bear a personal burden for people who need practical or spiritual help. Welcoming international students, providing access for students from underprivileged communities, reserving financial aid for families with high need, caring for students with disabilities, pursuing racial reconciliation, ensuring student access to physical and mental health care, giving comfort in times of personal or institutional tragedy—these presidential priorities reflect the empathy of Jesus Christ. When college presidents advocate effectively for the needs of faculty, staff, and students, they fulfill Christ's priestly office on campus.

People often say "it's lonely at the top," and sometimes it is. However, it doesn't have to be, and in the common priesthood of the Christian church it really shouldn't be. The assumptions that hobbits make about friendship and companionship challenge our tendency to self-sufficiency. If God has given us anything important to accomplish, we should not expect to have all the abilities to complete our assignment or to get it done all by ourselves without the encouragement of others. This is true for every one of us, in every calling.

A good example comes from Tolkien's own life. The author placed a very high value on personal friendship and also on nurturing his calling as a writer in the context of Christian community.

For nearly two decades Tolkien met weekly with Christian writers in Oxford who called themselves "the Inklings." C. S. Lewis, Charles Williams, and others would gather informally at a local pub or in college lodgings to talk about life and theology and to read and critique one another's work. It is safe to say that *The Lord of the Rings* never would have been published without the encouragement of C. S. Lewis specifically. Tolkien acknowledges this in one of his letters to Clyde S. Kilby when he writes, "But for the encouragement of C.S.L. I do not think that I should ever have completed or offered for publication *The Lord of the Rings*."[154] George Sayer also appears to have had an important role in bringing *The Lord of the Rings* to life. On a 1952 visit to Sayer's house in Malvern, Tolkien reluctantly agreed to read some of his poems and stories into a tape recorder. At the time, he had all but given up hope that his great novel would ever be published, but hearing his work out loud encouraged Tolkien enough to send his manuscript to a former pupil, Rayner Unwin, and the rest is history.[155] To put the point more boldly, without the priestly ministry of Christian friendship, J. R. R. Tolkien never would have completed his life's work for the kingdom of God.

Like Lewis and Tolkien, and Frodo and Sam, all of us are part of a story much bigger than ourselves.[156] Perhaps we will find the world crumbling around us, as they did, and yet also find the

[154]Tolkien, *Letters*, 366 (no. 282). In a letter to Professor Francis Anderson, Lewis described his influence on Tolkien like this: "I didn't influence *what* he wrote. My continued encouragement, carried to the point of nagging, influenced him very much to write at all with that gravity and at that length. In other words, I acted as a midwife, not as a father" (Kilby, *Tolkien & "The Silmarillion*," 76). To learn more about the friendship that these authors shared, see Philip Zaleski and Carol Zaleski, *The Fellowship: The Literary Lives of the Inklings: J.R.R. Tolkien, C. S. Lewis, Owen Barfield, Charles Williams* (New York: Farrar, Straus and Giroux, 2015).

[155]Liner notes to J. R. R. Tolkien, *J. R. R. Tolkien Reads and Sings His "The Hobbit" and "The Fellowship of the Ring*," Caedmon Records, 1975.

[156]*TT*, 696-97.

courage somehow to carry on. The words that Gandalf spoke to Frodo when he first undertook his priestly burden sound prophetic for Christians today: "You may be sure that it was not for any merit that others do not possess: not for power or wisdom, at any rate. But you have been chosen, and you must therefore use such strength and heart and wits as you have."[157] Thank God we are none of us limited to our own minds and hearts and wills, but we belong to the priesthood of all believers.

[157] *FR*, 60.

Response

JENNIFER POWELL MCNUTT

We stand today at the convergence of two anniversaries, for the Wade Center recently celebrated its fiftieth anniversary, and the five hundredth anniversary of the Reformation is nearly upon us. Regarding the first of these anniversaries, in my own life, I discovered the Wade authors through Lewis's The Chronicles of Narnia as a child, and I walked into my fair share of wardrobes hoping against all odds that I might somehow stumble into that magical world. It was not until college that I began to discover the richness of other Wade authors and their works, such as George MacDonald's *Phantastes*, Charles Williams's *War in Heaven*, and eventually Tolkien's *The Lord of the Rings*.

Recently, there was a fascinating article in *The Atlantic* titled "Why the British Tell Better Children's Stories."[158] After conducting a comparison of popular children's stories in Britain and America, Colleen Gillard highlights the enchanted, imaginative world of British children's literature as differing noticeably from the pragmatic, moralistic stories of America. Perhaps this is the reason for the American tendency to allegorize Tolkien discussed by Dr. Ryken. Apparently, current psychologists claim that the world of fantasy is better suited to childhood development. By that reasoning, then, it seems that although Americans have surely benefited from the tales of Laura Ingalls Wilder, we still

[158]Colleen Gillard, "Why the British Tell Better Children's Stories," *Atlantic*, January 6, 2016, www.theatlantic.com/entertainment/archive/2016/01/why-the-british-tell-better-childrens-stories/422859/.

need myth-making—*mythopoeia*, as Tolkien called it[159]—as an essential part of working out human life in its many facets beyond the pragmatic.

As the Wade authors exemplify, thinking imaginatively is an opportunity to think theologically. So I deeply resonate with Dr. Ryken's reflection on Frodo and the hobbits as an illustration of the priesthood of all believers. As he carefully drew out from the text, Frodo is indeed the unlikely hero, who has been given a tremendous task. Unassuming, unpretentious, and even unattractive, Frodo is the ordinary chosen to fulfill an extraordinary purpose. I was again struck by Tolkien's description of the Council of Elrond in Rivendell, when Frodo felt his destiny like a "great dread" falling on him "as if he was awaiting the pronouncement of some doom that he had long foreseen and vainly hoped might after all never be spoken."[160]

The full weight of this dread, however, would only be felt if Frodo had entered that impossible task alone. As Dr. Ryken highlighted, we are reliant on others, for we are part of a priestly people. At first the Fellowship embodies that priestly network of believers through the unlikely alliance forged between hobbits, humans, elves, and dwarves—each one equipped with different gifts and different roles while united (for a time) in dedication to a single purpose. Even when, like Christ's disciples at the hour of his arrest, the Fellowship is scattered, the community of priests persists through Frodo's friendship with Sam, who willingly journeys to what he believes will be his death alongside Frodo. This is priestly service—laying down one's very life for another.

[159]See Tolkien's poem, "Mythopoeia," in *Tree and Leaf* (London: Unwin Hyman, 1998), 97-101; and "On Fairy-Stories," in *The Monsters and the Critics and Other Essays* (London: Harper Collins, 1997), 109-61.

[160]*FR*, 263.

And yet, in the end, Frodo falls prey to temptation. As much as we might like for him to succeed, Frodo is not, as Dr. Ryken acknowledges, the perfect savior. One can't help but admire Frodo immensely, despite his imperfection. For the purposes of this response essay, I would like to highlight the way Frodo's faltering particularly resonates with the primary motivation behind the Protestant Reformation's advancement of the threefold office of Christ and the priesthood of all believers more than any direct victory on Frodo's part would have. Indeed, it is in this strange paradox of Frodo's defeat and victory through which the Reformation message can powerfully shine.

Turning to the second anniversary, five hundred years ago, Martin Luther was—like Frodo—an unlikely character in an unfolding drama in which he would become the central figure. In Luther we encounter an unknown monk in a small town at a no-name university who set off a transformation of the church and of the hearts, minds, and lives of Christians that would prevail to this very time and place. But it is important to bear in mind that Luther's advancement of the concept of the priesthood of all believers was something of a shock to a society closely governed by a hierarchy of orders from clergy to nobility to commoners. It was not that the idea had never been known in Christian history. On the contrary, although the Protestant Reformation especially developed and promoted the concept of the priesthood of all believers, the idea itself had earlier origins within Christianity. The notion first emerged in the writings of early church fathers and texts, including Clement of Rome, the Didache, Polycarp, Justin Martyr, Irenaeus, the Epistle to Diognetus, Clement of Alexandria, Tertullian, Origen, Cyprian, John Chrysostom, and Augustine—just to name a few.[161]

[161] See, for example, Hank Voss, *The Priesthood of All Believers and the Missio Dei: A Canonical, Catholic, and Contextual Perspective*, Princeton Theological Monograph (Eugene, OR:

Moreover, by the late medieval period, there was already a push against a growing demotion of the laity in spiritual matters, which was perhaps best captured in the withholding of the Communion cup. Before Luther, Erasmus wielded the tools of humanism to advocate for the education of the laity, particularly in his *Handbook of a Christian Knight*. In more ways than one, Erasmus paved the way for Luther.[162] Nonetheless, Luther's advancement of the priesthood of all believers had a much larger purpose and far greater impact. It was as though the temple veil was split again from top to bottom and the holy of holies was popularized yet again. But for Luther the veil was three walls. Luther's *To the Christian Nobility of the German Nation* was the first of his three theological treatises in 1520, which, unbeknownst to him, would lead him directly to his hearing at the Diet of Worms the following year after being excommunicated in January. There, Luther detailed how three walls were preventing the church from reform—the pope's monopoly over the interpretation of Scripture, the pope's control over the calling of a reforming council, and the spiritual dividing of the society of orders.[163]

In response to this predicament, Luther empowered the nobility to reform the church by advancing the spiritual value and equality of all people within the church. In so doing, he also advanced a spiritual dignity to the daily life and work of everyday Christians, though he maintained that their function within the body of

Pickwick, 2016) and Vittorino Grossi, "Priesthood of Believers," in *Encyclopedia of Ancient Christianity*, vol. 3, ed. Angelo Di Berardino (Downers Grove, IL: IVP Academic, 2014), 302-4.

[162]Erasmus's letter from 1523 mentions the contemporary view that "Erasmus laid the egg that Luther hatched." See Robert Henry Murray, *Erasmus and Luther: Their Attitude to Toleration*, Society for Promoting Christian Knowledge (New York: MacMillan, 1920), 213.

[163]Martin Luther, *To the Christian Nobility of the German Nation* (1520), ed. James Estes and Timothy J. Wengert, The Annotated Luther: Study Edition (Minneapolis: Fortress, 2016), 369-466.

believers would vary by office. For Luther, the divisions of status that were explicit in the society of orders were illusory in terms of our spiritual life. Thus, he declared, "All Christians are truly of the spiritual estate, and there is no difference among them except that of office."[164] Above all, baptism marked this shared priestly consecration of believers. Moreover, while all were granted the right of conscience in matters of faith, Luther still stressed the necessity of evaluating faith in community. Indeed, for Luther, the very freedom of the Christian was paradoxical as the believer is both freed from all in Christ and at the same time enslaved to all in Christ.[165] This correlates with Dr. Ryken's point that the friendships of the hobbits make them an ideal illustration of the priesthood of all believers. Like them, we were never meant to bear our burdens alone.

And yet, even though we enter into the office of priest, our work is still derivative of the work of Christ. The very fact that Frodo does not directly succeed in his purpose highlights the importance that while we are participants in the work of God and the advancement of his kingdom, we are, in the end, insufficient. The perseverance of the saints is brought to an effectual end through the sovereignty of God and the work of Christ alone—the primary focus of the Reformation message. In fact, this emphasizes the Protestant Reformation's original purpose in highlighting the offices of Christ as a means of stressing the absolute fulfillment that Christ alone brings to humanity. For Protestants, the late medieval traditions were increasingly putting the sufficiency of the person and work of Christ in jeopardy. Thus, the Reformers went to great lengths to stress his unique fulfillment of these offices.

[164]Ibid., 381.

[165]Martin Luther, *The Freedom of a Christian* (1520), ed. Timothy J. Wengert, The Annotated Luther: Study Edition (Minneapolis: Fortress, 2016).

True, there were priests before Christ, and there have been priests since Christ, but Christ is the only priest who gave himself as the perfect, sinless sacrifice in order to be sin (2 Cor 5:21) and thereby overcome sin (Heb 9:14) for us and our salvation. It is thus Christ alone who properly fulfills this office. The priesthood of Frodo is powerfully compelling and Christlike in numerous ways, and the fact that he falls short in the end does not—ultimately—disappoint. On the contrary, whether Tolkien had any such schema in his mind or not, it points us to the one who did not fall short on our behalf. And it reminds us that we are ennobled by Christ alone as we seek to follow him together, a priestly band of fellow travelers.

3

ᵀʰᵉ CORONATION *of* ARAGORN
SON *of* ARATHORN

𝔍 n the heart of the king there is room for only one true love. Aragorn son of Arathorn has pledged his undying affection to Arwen, Evenstar, the fair daughter of Elrond.

The love story of Arwen and Aragorn occupies surprisingly little space in *The Lord of the Rings*. Most of the romantic action happens offstage—a fact that has led some critics to wonder whether Tolkien was as adept at developing female characters as he was at portraying male friendship. The long-separated lovers do not even plight their troth to one another in the novel; we have to get the backstory from an appendix.[1] All we catch in the pages of *The Lord of the Rings* are occasional glimpses of their passionate relationship.

We first meet Arwen in the great hall of Rivendell, where her fair beauty captivates Frodo's gaze. Few mortals had yet beheld the light of the stars in her bright gray eyes. Many—including Aragorn—saw her as the second coming of Lúthien, the most beautiful of all the Children of Ilúvatar.[2] For his part, Frodo could

[1] J. R. R. Tolkien, "Here Follows a Part of the Tale of Aragorn and Arwen," part 3 of appendix A, "Annals of the Kings and Rulers," in *RK*, 1035.
[2] Ibid., in *RK*, 1033.

only say that he had never imagined "such loveliness in living thing."[3] Later, he is surprised to see Aragorn standing beside her chair and speaking with her at the throne of her father, Elrond.[4]

Although they do not speak again until the end of the novel, Aragorn's faithful love for Arwen operates as a powerful motivator in his quest for kingship. The future king's sad departure from Rivendell brings with it a burden of sorrow that he will carry for the rest of his journey.[5] He has left his heart in Rivendell.[6] In Lothlórien he holds a golden bloom of *elanor* and treasures the memory of standing with Arwen in former days on the hill of Cerin Amroth.[7] There he meets Lady Galadriel, Arwen's grandmother. She gives him a sheath for Andúril, the sword that "shall not be stained or broken, even in defeat."[8] When she asks what else he wishes to receive, Aragorn says, in reference to Arwen, "Lady, you know all my desire, and long held in keeping the only treasure that I seek. Yet it is not yours to give me, even if you would; and only through darkness shall I come to it."[9] What Galadriel *is* able to give him is the Elfstone of the house of Elendil—the gemstone that serves as a promise of Arwen's love and a token of Aragorn's rightful kingship.

After Lórien, Arwen all but disappears from the adventure. Yet she is not forgotten. We know that one day Arwen and Aragorn will become husband and wife. Victory in battle and coronation to a kingdom are not enough. This is a story that will not and cannot come to a satisfying conclusion without a royal wedding.

[3]*FR*, 221.
[4]*FR*, 232.
[5]*FR*, 273.
[6]See *FR*, 197.
[7]*FR*, 343; cf. *RK*, 1035.
[8]*FR*, 365.
[9]*FR*, 365.

The expectation of these nuptials provides unexpected suspense near the end of the novel, when the victors return from battle. Frodo, Sam, and other members of the Fellowship of the Ring receive a hero's welcome. Aragorn comes to the city of Minas Tirith and is crowned its rightful king. Then the pace of narrative slows as we wait for something unspecified to happen. Some of the main characters grow impatient to return to their homelands. Yet they remain in Gondor, waiting, for their king says, "A day draws near that I have looked for in all the years of my manhood, and when it comes I would have my friends beside me."[10]

Finally, on the Eve of Midsummer, the happy day arrives. Aragorn proclaims, "Let all the City be made ready!" A long procession of fair elves arrives from every corner of Middle-earth. The last to arrive is Elrond, the father of the bride, with Arwen riding beside him on a gray palfrey. When Frodo sees her "come glimmering in the evening, with stars on her brow," he tells Gandalf, "At last I understand why we have waited! This is the ending. Now not day only shall be beloved, but night too shall be beautiful and blessed and all its fear pass away!" And so it was that "Aragorn the King Elessar wedded Arwen Undómiel in the City of the Kings upon the day of Midsummer, and the tale of their long waiting and labours was come to fulfilment."[11]

This wedding scene brings the love story of Arwen and Aragorn to its joyous conclusion. It also completes a narrative arc that retraces the trajectory of redemptive history. The Bible, too, is a love story that ends with a royal wedding—the story of a long-awaited king who enters a golden city to take his rightful throne and then claim his one true love as his long-awaited bride (Rev 21–22). Thus

[10]*RK*, 948-49.
[11]*RK*, 951; cf. 1036-37.

the kingship of Aragorn son of Arathorn serves as another image of the Messiah in Middle-earth.

THE THIRD AND FINAL OFFICE

With Aragorn's coronation, we conclude our reading of *The Lord of the Rings* according to the threefold office of Christ as prophet, priest, and king.

Starting with Eusebius of Caesarea in the fourth century, the church has viewed Jesus of Nazareth as the personal fulfillment of everything the Bible promises about prophetic, priestly, and kingly ministry. The prophets, priests, and kings of the Old Testament anticipated the prophetical, sacerdotal, and royal dimensions of Christ's saving work.

Together these three offices address the full extent of our need for a Savior. For John Wesley, the father of Methodism, the present work of the exalted Christ is essential to moral transformation.[12] Having made atonement, Jesus the priest now intercedes for us in our struggle with remaining transgression. As prophet he restores our knowledge of the will of God, which enables us to overcome the power of sin. As victorious king he graciously commands a law for us to obey and then reigns in us until finally we surrender everything to him.

With the goal of our entire sanctification in view, Wesley exhorted preachers to proclaim Christ "in all his offices"[13] and thus to address humanity in all its need:

> We are by nature at a distance from God, alienated from Him, and incapable of a free access to Him. Hence we want a Mediator,

[12]See John Deschner, *Wesley's Christology: An Interpretation* (Dallas: Southern Methodist University Press, 1960).

[13]Randy L. Maddox, *Responsible Grace: John Wesley's Practical Theology* (Nashville: Abingdon, 1994), 109-14.

an Intercessor; in a word, a Christ in His priestly office. This regards our state with respect to God. And with respect to ourselves, we find a total darkness, blindness, ignorance of God and the things of God. Now here we want Christ in His prophetic office, to enlighten our minds, and teach us the whole will of God. We find also within us a strange misrule of appetites and passions. For those we want Christ in His royal character, to reign in our hearts, and subdue all things to Himself.[14]

Like John Wesley, John Henry Newman saw pastoral benefit in preaching Christ in all his offices. In his 1840 Easter sermon, "The Three Offices of Christ," the Oxford theologian argued that the threefold ministry of Christ corresponds in some way to every person's situation:

> These three offices seem to contain in them and to represent the three principal conditions of mankind; for one large class of men, or aspect of mankind, is that of sufferers,—such as slaves, the oppressed, the poor, the sick, the bereaved, the troubled in mind; another is, of those who work and toil, who are full of business and engagements, whether for themselves or for others; and a third is that of the studious, learned, and wise. Endurance, active life, thought,—these are the three perhaps principal states in which men find themselves. Christ undertook them all.[15]

To summarize, the prophetic, priestly, and kingly ministries of Jesus Christ satisfy humanity's deep need for guidance, care, and protection.

[14]John Wesley, note on Mt 1:16, in *Explanatory Notes upon the New Testament* (1754; repr., London: Epworth, 1976), 16. See also Wesley's "*Sermon 31*, 1.6," as cited by Deschner, *Wesley's Christology*, 209, in which the evangelist commends preaching Christ as "our great High Priest," "the Prophet of the Lord," and "a King for ever."

[15]John Henry Newman, "The Three Offices of Christ," in *Sermons, Bearing on Subjects of the Day* (London: Gilbert and Rivington, 1843), 61.

The free peoples of Middle-earth have similar needs, which are not satisfied by a singular savior but are met instead by the combined efforts of multiple protagonists. Through his wise words of guidance and miraculous acts of deliverance, Gandalf the Grey fulfills the role of a prophet. Together Frodo and Sam nobly carry out the sacred priestly duty of bearing a burden unto death. But people also need a king. No one believed this more strongly than J. R. R. Tolkien, who as a matter of principle was deeply committed to monarchy, both in life and in literature.[16] Indeed, the author once described "tyranny against kingship" as one of the main themes of his magnum opus.[17] So the salvation of Middle-earth cannot be complete until Aragorn returns to his royal city in triumph.

To draw connections between Tolkien's main protagonists and the ministry of Jesus Christ is not to say that the author wrote his story with these connections in mind, as though he were using fiction as a vehicle for systematic theology. "Tolkien was very careful," writes Stratford Caldecott, "in trying to construct his world in a way that would faithfully echo the wisdom of the true Creator, as he understood God to be, yet without anticipating the specific content of Christian revelation. For that revelation had not yet taken place."[18]

But in making a new world, a Christian writer inevitably reflects and refracts biblical truth. W. H. Auden illuminates the unmistakable presence of the gospel in Tolkien's fiction when he states

[16]See Christopher Scarf, *The Ideal of Kingship in the Writings of Charles Williams, C.S. Lewis and J.R.R. Tolkien: Divine Kingship as Reflected in Middle-Earth* (Cambridge: James Clarke, 2013).

[17]J. R. R. Tolkien, *The Letters of J.R.R. Tolkien*, ed. Humphrey Carpenter (Boston: Houghton Mifflin, 2000), 178 (no. 144).

[18]Stratford Caldecott, *The Power of the Ring: The Spiritual Vision Behind "The Lord of the Rings" and "The Hobbit,"* 2nd ed. (New York: Crossroad, 2012), 84.

that "the unstated presuppositions" of *The Lord of the Rings* are all Christian.[19] Tolkien's calling, as the author himself understood it, was to serve as a sub-creator under the lordship of Christ as his Creator-God.[20] On the one hand, Tolkien insisted that his fiction had no overriding message, "if by that you mean the conscious purpose . . . of preaching or of delivering myself of a vision of truth." He was "primarily writing an exciting story," the kind of story that he found "personally attractive." Yet on the other hand Tolkien readily admitted that "in such a process inevitably one's own taste, ideas and beliefs get taken up."[21] So it is not surprising for us to see images of Christ in Middle-earth, including images of eternal kingship. The kind of story that Tolkien found "personally attractive"—and thus the kind of story that he wrote—was one in which a great king sacrifices himself to gain a kingdom.

THE KING PROPHESIED

From Saul to Zedekiah, the biblical kings were called to shepherd God's people and rule his earthly kingdom by providing for the people, protecting the nation, and rendering righteous judgment. But the Old Testament prophets announced the coming of a consummate king: a global ruler for David's eternal dynasty (2 Sam 7:12-16; cf. Jer 33:14-26), whose nativity was promised to royal Bethlehem (Mic 5:2). This king—this Christ—would rule the nations (Ps 2:7-9; 1 Sam 2:10), making his enemies his footstool (Ps 110:1). When the time was right, he would make his royal entrance into Jerusalem on a donkey (Zech 9:9-10; cf. 1 Kings 1:32-39). Isaiah prophesied:

[19]W. H. Auden, quoted in Clyde S. Kilby, *Tolkien & "The Silmarillion"* (Wheaton, IL: Harold Shaw, 1976), 58-59.

[20]J. R. R. Tolkien, "On Fairy-Stories," in *Tree and Leaf* (New York: HarperCollins, 2001), 47.

[21]Tolkien, *Letters*, 267 (no. 208).

> Of the increase of his government and of peace
> there will be no end,
> on the throne of David and over his kingdom,
> to establish it and to uphold it . . .
> from this time forth and forevermore. (Is 9:7)

As the centuries passed and Israel fell into the hands of powerful oppressors, God's faithful people nevertheless looked in hope for the return of their king.

Under the tyranny of Sauron, Middle-earth felt a similar longing. The prologue introduces this theme when it tells us that "there had been no king for nearly a thousand years."[22] To be sure, the long delay caused some to give up hope. In the Shire, for example, the hobbits "chose a Thain to take the place of the King, and were content; though for a long time many still looked for the return of the King. But at last that hope was forgotten, and remained only in the saying *When the King comes back*, used of some good that could not be achieved, or of some evil that could not be amended."[23]

Others continued to hope against hope and look for the return of a king. We see this hope in Faramir, the Captain of Gondor, who tells Frodo: "For myself, I would see the White Tree in flower again in the courts of the kings, and the Silver Crown return, and Minas Tirith in peace: Minas Anor again as of old, full of light, high and fair, beautiful as a queen among other queens: not a mistress of many slaves."[24] It was said that the White Tree would not flower again in the royal courts of Minas Tirith "until the King returns."[25]

[22]*FR*, 9.

[23]J. R. R. Tolkien, "Eriador, Arnor, and the Heirs of Isildur," part 1, sec. 3 of appendix A, "Annals of the Kings and Rulers," in *RK*, 1018.

[24]*TT*, 656.

[25]J. R. R. Tolkien, "Gondor and the Heirs of Anarion," part 2, sec. 4 of appendix A, "Annals of the Kings and Rulers," in *RK*, 1029.

Hope was kept alive only by prophecies of the king's return. The most famous was the one that Gandalf wrote down in a postscript to the letter he left for Frodo at the Prancing Pony—the letter that old Barliman Butterbur nearly forgot. Though Frodo and the other hobbits failed to understand it, the poem was meant to reveal Strider's true identity as Gondor's rightful king:

All that is gold does not glitter,
 Not all those who wander are lost;
The old that is strong does not wither,
 Deep roots are not reached by the frost.
From the ashes a fire shall be woken,
 A light from the shadows shall spring;
Renewed shall be the blade that was broken,
 The crownless again shall be king.[26]

Bilbo stands up and repeats this poetic prophecy at the Council of Elrond.[27]

Many other prophecies were more specific. Some referred to the Elfstone that the king would wear as a token of his nobility—the green stone that Galadriel gave to Aragorn as a pledge from Arwen.[28] Others referred to Arwen herself, who would "not be the bride of any Man less than the King of both Gondor and Arnor."[29] Still others referred to the king's sword, Narsil, which broke under the weight of Sauron when he was struck down by Elendil, on the day Isildur cut the One Ring of Power from Sauron's bloody hand. The sword that Sauron never forgot would be reforged so that it

[26]*FR*, 167.
[27]*FR*, 241.
[28]*RK*, 853.
[29]Tolkien, "Aragorn and Arwen," in *RK*, 1036. See also Aragorn's retelling of the love story of Beren and Lúthien, which anticipates his own romance with Arwen and their fate (*FR*, 189-90).

could be wielded again by the one true king.[30] There was even a prophecy that the king would pass unscathed through the Paths of the Dead:

> *Over the land there lies a long shadow,*
> *westward wings of darkness.*
> *The Tower trembles; to the tombs of kings*
> *doom approaches. The Dead awaken;*
> *for the hour is come for the oathbreakers:*
> *at the Stone of Erech they shall stand again*
> *and hear there a horn in the hills ringing.*
> *Whose shall the horn be? Who shall call them*
> *from the grey twilight, the forgotten people?*
> *The heir of him to whom the oath they swore.*
> *From the North shall he come, need shall drive him:*
> *he shall pass the Door to the Paths of the Dead.*[31]

THE KING REJECTED

The royal prophecies of Middle-earth were intended to keep hope alive and also to help people recognize the return of the king. But when he finally came, people failed to perceive his true identity. What is worse, many rejected him.

The same is true in the Gospels, of course, where even the disciples are slow to recognize Jesus as the Christ. The legitimacy of his kingly claims was clear enough from his noble lineage (Mt 1:1-17; Lk 3:23-31), from his birth in Bethlehem, the city of David (Lk 2:4-7, 11), and from the adoration of the Magi, who wanted to worship the baby who was "born king of the Jews" (Mt 2:1-2). Jesus was the man born to be king—the

[30]*FR*, 242; *RK*, 763.
[31]*RK*, 764.

royal scion destined to rule on the never-ending "throne of his father David" (Lk 1:32-33). On occasion, faithful Israelites did honor Christ as their king. One thinks of the blind man who cried out, "Jesus, Son of David, have mercy on me" (Lk 18:38-39), or Peter's climactic confession of Jesus as the Christ (Mt 16:16), or the multitudes who gave him a royal welcome on Palm Sunday, when they shouted, "Hosanna to the Son of David!" (Mt 21:9), "Blessed is the coming kingdom of our father David!" (Mk 11:10), and "Blessed is the King who comes in the name of the Lord!" (Lk 19:38).

But Jesus of Nazareth was hardly the kind of king that people expected, so most of them despised him and rejected him. Their opposition came to a head at the crucifixion. First the Roman soldiers paid him mock homage with a robe of purple, a scepter of straw, a crown of thorns, and a sarcastic salute: "Hail, King of the Jews!" (Mt 27:27-31). When they saw the sign that Pilate posted on the cross, the religious leaders demanded some editorial changes: "Do not write, 'The King of the Jews,' but rather, 'This man said, I am King of the Jews'" (Jn 19:21). Then they added insult to injury by saying, "He saved others; he cannot save himself. He is the King of Israel; let him come down now from the cross, and we will believe in him" (Mt 27:42). In the hour of his death, especially, Jesus could not have been more ridiculed than he was. All who saw him mocked him (Ps 22:7), not only as king, but also as prophet and priest (see Mt 26:68; Lk 23:34-35).

The ascendancy of Aragorn follows a similar pattern. An alert reader might discern his true identity all the way back in Bree, at the Prancing Pony. Although Strider is first presented as a grim and mysterious stranger, Gandalf's letter explains that his true name is Aragorn, and prophesies that "the crownless again shall be

king."[32] But to the hobbits Strider is "only a Ranger,"[33] and someone not entirely to be trusted. Samwise Gamgee is especially doubtful: "He comes out of the wild, and I never heard no good of such folk."[34]

The hobbits are not the only characters who have their doubts about Aragorn. Boromir is tempted to pursue his own ambitions to the throne. Rather than destroying the One Ring of Power, he imagines claiming it for himself and becoming "a mighty king, benevolent and wise."[35] His brother Faramir is less ambitious but equally cautious. Could it be that Aragorn is Gondor's rightful king? "Maybe," Faramir says. "But so great a claim will need to be established, and clear proofs will be required, should this Aragorn ever come to Minas Tirith."[36] Their father Denethor is more dubious about Aragorn's ability to rule the kingdom: "Even were his claim proved to me, still he comes but of the line of Isildur. I will not bow to such a one, last of a ragged house long bereft of lordship and dignity."[37] Needless to say, Aragorn's enemies will not bow to Aragorn either but mock his claim to the kingship at the Black Gate of Morannon.[38]

The king's concealment was partly by design. There is, so to speak, a messianic secret in Middle-earth. From the tale that Tolkien tells about Aragorn and Arwen in one of his appendixes, we know that when the future king was two years old, "Elrond took the place of his father and came to love him as a son of his own. But he was called Estel, that is 'Hope,' and his true name and lineage were kept secret at the bidding of Elrond; for the Wise

[32]*FR*, 167.
[33]*FR*, 215.
[34]*FR*, 162.
[35]*FR*, 389.
[36]*TT*, 649.
[37]*RK*, 836.
[38]*RK*, 870.

then knew that the enemy was seeking to discover the Heir of Isildur, if any remained upon earth."[39] The king is kept concealed until the time comes for him to confront the power of Sauron and claim his rightful kingdom. In the intervening years, "his ways were hard and long, and he became somewhat grim to look upon, unless he chanced to smile; and yet he seemed to Men worthy of honour, as a king that is in exile, when he did not hide his true shape."[40]

We get perhaps the first inkling of Aragorn's kingly quality and royal mission at the Prancing Pony, when he throws back his cloak and shows his sword to Sam Gamgee and the other hobbits. "I am Aragorn son of Arathorn," he says; "and if by life or death I can save you, I will."[41] The words he speaks when the Fellowship of the Ring passes between the Argonath, the giant Pillars of the Kings that guard the river Anduin, are more direct: "Long have I desired to look upon the likenesses of Isildur and Anarion, my sires of old. Under their shadow Elessar, the Elfstone son of Arathorn of the House of Valandil Isildur's son, heir of Elendil, has nought to dread!"[42]

On several occasions, it is Aragorn's kingly demeanor (rather than his royal speech) that points to his true identity. When he receives the Elfstone in Lothlórien, for example, we are told that his traveling companions "had not marked before how tall and kingly he stood."[43] He displays the same regal bearing when they take to the river on their journey toward Mordor: "In the stern sat Aragorn son of Arathorn, proud and erect, guiding the boat with skillful strokes; his hood was cast back, and his dark hair was

[39]Tolkien, "Aragorn and Arwen," in *RK*, 1032.
[40]Ibid., in *RK*, 1035.
[41]*FR*, 168.
[42]*FR*, 384.
[43]*FR*, 366.

blowing in the wind, a light was in his eyes: a king returning from exile to his own land."[44]

Or consider what Gimli and Legolas witness when Aragorn confronts Éomer on the plains of Rohan. They "looked at their companion in amazement," for "in his living face they caught a brief vision of the power and majesty of the kings of stone. For a moment it seemed to the eyes of Legolas that a white flame flickered on the brows of Aragorn like a shining crown."[45] The elf and the dwarf see Aragorn in similar light in Fangorn Forest: "tall, and stern as stone, his hand upon the hilt of his sword; he looked as if some king out of the mists of the sea had stepped upon the shores of lesser men."[46]

There are more than enough clues that Aragorn is destined to take the throne. Any lingering doubts are removed when Gandalf gives him the Palantír, the seeing-stone that only kings have the right to bring under their mastery.[47] The wizard bows before Aragorn and says, "Receive it, lord!"[48]

Nevertheless, these clues are lost on the hobbits, who are slow to recognize Aragorn's royal calling. When Pippin expresses surprise that someone is coming to claim the kingship, Gandalf chides him by saying, "Yes. If you have walked all these days with closed ears and mind asleep, wake up now!"[49] Sam is equally confused. "The King?" he exclaims after his rescue from Mount Doom. "What king, and who is he?"[50] "The King of Gondor and the Lord of the Western Lands," Gandalf says in reply, "and he has taken back all

[44] *FR*, 384.
[45] *TT*, 423.
[46] *TT*, 489.
[47] See *RK*, 763.
[48] *TT*, 580.
[49] *RK*, 737.
[50] *RK*, 931.

his ancient realm. He will ride soon to his crowning, but he waits for you."[51] Soon Frodo and Sam are escorted to an outdoor throne, where they see their friend Aragorn seated before the banner of a white tree. In an instant "they knew him, changed as he was, so high and glad of face, kingly, lord of Men, dark-haired with eyes of grey." "Well, if this isn't the crown of all!" Sam says with astonishment. "Strider, or I'm still asleep!"[52] And of course it is the crown of all, for the true king is seated on his rightful throne.

ROYAL TITLES AND KINGLY QUALITIES

Aragorn's true identity is revealed further by the many regal titles that he is given throughout *The Lord of the Rings*, as well as by the kingly abilities he demonstrates and royal virtues he displays. Aragorn is introduced first as Strider, his familiar nickname, then as the Dunadan. "You seem to have a lot of names," Frodo remarks[53]—a comment that would apply equally well, if not better, to Jesus of Nazareth. This is even before the hobbit learns the rest of Aragorn's royal epithets, which rapidly accumulate.[54]

Only the greatest of kings could possibly deserve as many titles as Aragorn is given. He is Isildur's heir,[55] also known as Elessar, the Elfstone,[56] the "Chief of the Dúnedain in the North,"[57] and "the Lord of the White Tree."[58] He is called Elfstone "because of the green stone that he wore, and so the name which it was foretold at his birth that he should bear was chosen for him by his

[51]*RK*, 931; cf. 870.
[52]*RK*, 932.
[53]*FR*, 226.
[54]See Angela P. Nicholas, *Aragorn: J. R. R. Tolkien's Undervalued Hero* (Bedfordshire, UK: Bright Pen, 2012), 99-103.
[55]*FR*, 245; cf. *RK*, 859.
[56]*FR*, 366; cf. *RK*, 867.
[57]*FR*, 240.
[58]*RK*, 859.

own people."[59] In the house of Elrond he is also known as Estel, which means "Hope."[60] Later, when he vouches for Aragorn's kingly credentials before King Théoden in the golden hall of Rohan, Gandalf styles him "the heir of Kings" and "Elendil's heir" of Gondor.[61]

The king has begun to make similar claims for himself, as he does in the challenge he issues when he is outnumbered by Éomer and his men: "I am Aragorn son of Arathorn, and am called Elessar, the Elfstone, Dunadan, the heir of Isildur, Elendil's son of Gondor. Here is the Sword that was Broken and is forged again! Will you aid me or thwart me? Choose swiftly!"[62] This speech exemplifies the way that Aragorn's recognition of his royal identity and confidence in his kingly authority grow throughout the novel. We see this progression when he assumes leadership after the death of Gandalf,[63] when he first raises the sword Andúril to lead men into battle,[64] and when he claims the right to use the Palantír as his royal prerogative.[65]

Later, in the Houses of Healing, when Éomer addresses Aragorn as Strider, he gets criticized for being overfamiliar. But the king defends his friend by elevating his most common name to royal status. "In the high tongue of old I am *Elessar*, the Elfstone, and *Envinyatar*, the Renewer," he says. "But Strider shall be the name of my house, if that be ever established. In the high tongue it will not sound so ill, and *Telcontar* I will be and all the heirs of my body."[66]

[59] *RK*, 853; cf. 945.
[60] Tolkien, "Aragorn and Arwen," in *RK*, 1032.
[61] *TT*, 498, 499.
[62] *TT*, 423; cf. *RK*, 763.
[63] *TT*, 425.
[64] *TT*, 521.
[65] *RK*, 763.
[66] *RK*, 845.

Aragorn's ascent is paralleled by the growing affection of those who would become his loyal subjects. When Merry and Pippin are separated from the rest of the Fellowship and waiting for the Entmoot to end, they find themselves—somewhat to their surprise—longing for Strider's company.[67] Later in the novel Legolas says of their sometimes grim companion that "all those who come to know him come to love him after his own fashion."[68] Éowyn uses the same word to explain why the Riders of Rohan will follow Aragorn down the Paths of the Dead, against her better judgment: "They go only because they would not be parted from thee—because they love thee."[69] Such a king does not need to demand obedience; his character freely compels it. In the words of Imrahil, the fair Prince of Dol Amroth, "His wish is to me a command."[70]

Eventually, Aragorn's royal claims are acknowledged by everyone. The first citizen to honor his kingship is Faramir. When the warrior awakens from his sickbed, he opens his eyes to behold his king. "My lord, you called me," he says. "I come. What does the king command?" And when the king commands simply his readiness, the captain asks, "Who would lie idle when the king has returned?"[71] Later it will fall to Faramir, as Steward of Gondor, to announce publicly that the true king has come to claim his kingdom: "Here is Aragorn son of Arathorn, chieftain of the Dúnedain of Arnor, Captain of the Host of the West, bearer of the Star of the North, wielder of the Sword Reforged, victorious in battle, whose hands bring healing, the Elfstone, Elessar of the line of Valandil, Isildur's son, Elendil's son of Númenor."[72]

[67]*TT*, 471.
[68]*RK*, 856; cf. 948.
[69]*RK*, 767; cf. 769.
[70]*RK*, 862.
[71]*RK*, 848.
[72]*RK*, 945-46.

The mention of healing hands identifies Aragorn as the fulfillment of an ancient prophecy. We first learn of this prediction when Faramir is wounded in battle and an old woman of Gondor hopes against hope that he may be healed. "Alas!" she says, "if he should die. Would that there were kings in Gondor, as there were once upon a time, they say! For it is said in old lore: *The hands of the king are the hands of a healer.* And so the rightful king could ever be known."[73]

The full extent of the king's healing powers is foreshadowed on Weathertop, where Frodo receives a mortal blow from a blade forged in the dark shadows of Mordor. Strider calls for kingsfoil, an herb (also known as *athelas*) that has healing powers in the hands of those who know how to use it.[74] By saving Frodo's life, Aragorn demonstrates his kingly ability. Aragorn calls for kingsfoil again in the Houses of Healing, where he uses it to summon Faramir, Éowyn, and Meriadoc back from the gates of death. All three of them are saved by the coming of a king who has the power to heal.[75] This fulfills the ancient promise:

> *When the black breath blows*
> *and death's shadow grows*
> *and all lights pass,*
> *come athelas! come athelas!*
> * Life to the dying*
> *In the king's hand lying!*[76]

Word of Aragorn's healing power quickly spread, as it did when Jesus began to perform his healing miracles: "At the doors of the

[73]*RK*, 842 (italics original); cf. 844, 848, 935, 945.
[74]*FR*, 193.
[75]See *RK*, 842-50; cf. 937.
[76]*RK*, 847.

Houses many were already gathered to see Aragorn, and they followed after him; and when at least he had supped, men came and prayed that he would heal their kinsmen or their friends whose lives were in peril through hurt or wound, or who lay under the Black Shadow." When their loved ones are healed, people draw the obvious conclusion: "The King is come again indeed."[77] Aragorn has come as "the healer of the wounded people and the body politic of Gondor."[78]

The king's healing powers flow from a heart of pity. Of Aragorn's many royal qualities, the one mentioned most frequently is pity, which is a form of mercy.[79] The king has pity first of all for his rival Boromir. When Boromir gives in to the temptations of royal ambition, leading to his death at the hands of bloodthirsty orcs, Aragorn weeps openly over his proud and tragic downfall.[80] Pity for his beloved companions then leads the future king to track Merry and Pippin through the wilderness, where he hopes against hope to rescue the hobbits from captivity.[81]

The same gentle virtue motivates his care for Éowyn, the warrior princess who loves him with an unrequited love. At her sickbed in Minas Tirith, Aragorn tells her brother Éomer, "Sorrow and pity have followed me ever since I left her desperate in Dunharrow and rode to the Paths of the Dead."[82] When Éowyn awakens, she wishes that she had died in battle. But eventually she is persuaded not to scorn the royal pity that Aragorn extends

[77] *RK*, 853; cf. 848.

[78] Craig Bernthal, *Tolkien's Sacramental Vision: Discerning the Holy in Middle Earth* (Kettering, OH; Second Spring, 2014), 270.

[79] For a demonstration that Aragorn displays all four of the cardinal virtues, see David Rozema, "The Lord of the Rings: Tolkien, Jackson, and 'The Core of the Original,'" *Christian Scholar's Review* 37, no. 4 (Summer 2008): 433.

[80] *TT*, 404.

[81] *TT*, 409.

[82] *RK*, 849.

to her as "the gift of a gentle heart."[83] The king even pities the young men of Rohan when they are too afraid to go with him into battle; he pardons them rather than punishes them when they abandon him at Emyn Muil.[84] As these and many other examples show, Aragorn is not a king in name only, but also a king in heart and deed.

HAIL TO THE VICTOR!

The son of Arathorn waited patiently for many years to see his final triumph, which was long prophesied and sometimes foreshadowed. The hosts of Saruman caught a glimpse of his royal mien during the Battle of Helm's Deep, where "so great a power and royalty was revealed in Aragorn, as he stood there alone above the ruined gates before the host of his enemies, that many of the wild men paused, and looked back over their shoulders to the valley, and some looked up doubtfully at the sky."[85] Sauron's soldiers had similar doubts during the Battle of Pelennor Fields, when "Aragorn came up from the sea and unfurled the standard of Arwen" on the "day he was first hailed as king."[86]

But the warrior-king could not fully claim his rightful crown until he gained victory in battle. Only then would his kingship be acknowledged by all his subjects and secured in the presence of all his foes.[87] So Aragorn had resolved not to enter the city of Minas Tirith or make any claim to his kingship until it was certain

[83]*RK*, 943.

[84]*RK*, 868.

[85]*TT*, 528.

[86]Tolkien, "Aragorn and Arwen," in *RK*, 1036.

[87]According to the Germanic ideals of kingship that seem to be operative in Middle-earth, a king holds the royal office not merely by primogeniture but by demonstrating his worth through victory in battle. See Judy Ann Ford and Robin Anne Reid, "Councils and Kings: Aragorn's Journey Towards Kingship in J. R. R. Tolkien's *The Lord of the Rings* and Peter Jackson's *The Lord of the Rings*," *Tolkien Studies* 6 (2009): 74-75.

whether he or Sauron would prevail.[88] The chosen king was never presumptuous but patiently persevered until the kingdom was fully and rightfully his. On the fields of Rohan, when Aragorn catches a glimpse of his kingdom's distant mountains, he says, "Gondor! Gondor! Would that I looked on you again in happier hour! Not yet does my road lie southward to your bright streams."[89] Later, when Gandalf presses him to take the Orthanc-stone, which as king it is his right to use, Aragorn protests: "When have I been hasty or unwary, who have waited and prepared for so many long years?"[90]

At times the king's cause seems hopeless. Early in *The Two Towers*, when the Fellowship is broken and Aragorn fears that Merry and Pippin have been carried off by orcs, he tells Gimli and Legolas that they must ride on to avenge their companions, even if there may be no hope that the hobbits will be rescued.[91] Here Christopher Scarf sees Tolkien borrowing the pagan ideal of kingship such as we find in *Beowulf*, in which the hero offers "absolute resistance, perfect because without hope."[92]

Yet Aragorn is never without hope. Indeed, "hope" is the meaning of his Elvish name Estel. At Helm's Deep, when the Riders of Rohan grimly wait for battle in the face of overwhelming odds, he fulfills his kingly duty by going around and "enheartening the men."[93] Knowing that their fortress has never fallen while men were willing to stand to its defense, he says, "Then let us defend it, and hope!"[94] Aragorn's hope finds deep strength in the love of

[88] *RK*, 843.
[89] *TT*, 412.
[90] *TT*, 580.
[91] *TT*, 417.
[92] J. R. R. Tolkien, *Beowulf: The Monsters and the Critics*, quoted in Scarf, *Ideal of Kingship*, 119.
[93] *TT*, 527.
[94] *TT*, 525.

Arwen. When the fair princess tells him that he will be "among the great whose valour will destroy" the Dark Shadow, her betrothed confesses that he cannot imagine how this will ever come to pass. "Yet with your hope I will hope," he says.[95]

Nothing seems more hopeless than Aragorn's journey through the Paths of the Dead, where he awakens the ghosts of armies past to aid him in his final assault on the minions of Sauron. Like Gandalf (who is dragged into the abyss by the Balrog) and like Frodo (who lays down his life by traveling to Mount Doom), Aragorn is called to pass through death before he comes back to life. As we have seen, this is part of the ancient prophecy: the true king will "pass the Door to the Paths of the Dead."[96] Gandalf carries a similar prophecy from Galadriel to Aragorn after his own passage from death to life:

> *Near is the hour when the Lost should come forth,*
> *And the Grey Company ride from the North.*
> *But dark is the path appointed for thee:*
> *The Dead watch the road that leads to the Sea.*[97]

Aragon has faith in the ancient prophecies. Deep down, he knows that there is only one passageway that will bring him through the mountains to the coastlands before all is lost, and that is the Paths of the Dead.[98] As he weighs his options, he receives a reminder from Elrond that he should "remember the Paths of the Dead." The messenger also brings a gift from Arwen: the royal standard that she has fashioned for him in secret. She too has a message: "*The days now are short. Either our hope cometh,*

[95]Tolkien, "Aragorn and Arwen," in *RK*, 1035.
[96]*RK*, 764.
[97]*TT*, 491.
[98]*RK*, 763.

or all hopes end. Therefore I send thee what I have made for thee. Fare well, Elfstone!"[99]

As Aragorn prepares for his long-awaited hour, Éomer tries to dissuade him from taking the deadly road. But Aragorn knows that his destiny requires a journey to the underworld.[100] Upon learning of his intentions, "Éowyn stared at him as one that is stricken, and her face blanched." After a long pause, she says, "But Aragorn, is it then your errand to seek death? For that is all that you will find on that road. They do not suffer the living to pass."[101] Yet Aragorn remains resolute: "There is a road out of this valley, and that road I shall take. Tomorrow I shall ride by the Paths of the Dead."[102] As Jesus set his face toward Jerusalem and the cross (Lk 9:51), so Aragorn follows the road that he is destined to travel, even if it leads to certain death. When Merry and Éowyn seek an explanation for this fateful choice, Théoden says, "Maybe he was called. . . . He is a kingly man of high destiny."[103]

The king not only passes through the Paths of the Dead but summons forth a dread army of the undead to wage one final battle and deliver Gondor from the siege-engines of Sauron. Aragorn's grim subjects arrive by ship to unfurl the banner of a White Tree with Seven Stars and a high golden crown: "Thus came Aragorn son of Arathorn, Elessar, Isildur's heir, out of the Paths of the Dead, borne upon a wind from the Sea to the kingdom of Gondor."[104] The king has returned to his kingdom. In losing his life, he saves it, and also the life of his kingdom.

[99]*RK*, 758 (italics original).
[100]*RK*, 756.
[101]*RK*, 766.
[102]*RK*, 766.
[103]*RK*, 780.
[104]*RK*, 829.

There is one battle yet to fight, of course, which Aragorn takes straight to the hellish gates of Mordor. And then afterward, when victory is secure, he returns to the fair gates of Gondor, where he waits one more night before making his royal entrance. Tolkien was captivated by what he described in one of his letters as "the return in majesty of the true King."[105] He awakens our own sense of anticipation with his dramatic description of the eve of Aragorn's coronation: "And there in the midst of the fields they set up their pavilions and awaited the morning; for it was the Eve of May, and the King would enter his gates with the rising of the Sun."[106] We are reminded of Psalm 24, with its repeated refrain: "Lift up your heads, O gates! And be lifted up, O ancient doors, that the King of glory may come in."

THE KING RECEIVES HIS CROWN

The next day the city "made ready for the coming of the King."[107] A great eagle brings tidings of his triumph on the beams of the sun. This is the psalm he sings:

> *Sing now, ye people of the Tower of Anor,*
> *for the Realm of Sauron is ended for ever,*
> *and the Dark Tower is thrown down.*

> *Sing and rejoice, ye people of the Tower of Guard,*
> *for your watch hath not been in vain,*
> *and the Black Gate is broken,*
> *and your King hath passed through,*
> *and he is victorious.*

> *Sing and be glad, all ye children of the West,*
> *for your King shall come again,*

[105]Tolkien, *Letters*, 160 (no. 131).
[106]*RK*, 936.
[107]*RK*, 942.

and he shall dwell among you
 all the days of your life.

And the Tree that was withered shall be renewed,
 and he shall plant it in the high places,
 and the City shall be blessed.

Sing all ye people![108]

And so "the people sang in all the ways of the City."[109] For if the return of the king is something to celebrate, then it must be something to sing about. This was Tolkien's deep conviction as a Christian. In one of his letters he wrote:

> So it may be said that the chief purpose of life, for any one of us, is to increase according to our capacity our knowledge of God by all the means we have, and to be moved by it to praise and thanks. To do as we say in the *Gloria in Excelsis*: Laudamus te, benedicamus te, adoramus te, glorificamus te, gratias agimus tibit propter magnam gloriam tuam. We praise you, we call you holy, we worship you, we proclaim your glory, we thank you for the greatness of your splendor.
>
> And in moments of exaltation we may call on all created things to join in our chorus, speaking on their behalf, as is done in Psalm 148, and in The Song of the Three Children in Daniel II. PRAISE THE LORD . . . all mountains and hills, all orchards and forests, all things that creep and birds on the wing.[110]

What Tolkien gives us in *The Lord of the Rings* is nothing less than an eschatological celebration of an enduring kingdom. His

[108]*RK*, 942.
[109]*RK*, 942.
[110]Tolkien, *Letters*, 400 (no. 310).

religious vision "begins in a garden [the Shire] and ends in a great city [Minas Tirith], one with mighty walls, a river, and the Tree of Life."[111] The royal city is restored. Its streets are paved with white marble; its gardens are planted with green trees by cool fountains.[112] The whole gleaming citadel is "filled again with women and fair children that returned to their homes laden with flowers; and from Dol Amroth came the harpers that harped most skillfully in all the land; and there were players upon viols and upon flutes and upon horns of silver, and clear-voiced singers from the vales of Lebennin."[113]

The climactic event is the coronation. Dressed in a pure white mantle, Aragorn prepares to receive the ancient white crown, set with seven gems and a jewel of fire. But to the "wonder of many," he does not crown himself as king. Instead, he insists that the friends who helped him come into his inheritance should bestow this honor. So "Frodo came forward and took the crown from Faramir and bore it to Gandalf; and Aragorn knelt, and Gandalf set the White Crown upon his head."[114] For a moment, the people stare in silent wonder. For it seems that the king who has labored in secret for long years "was revealed to them now for the first time. Tall as the sea-kings of old, he stood above all that were near; ancient of days he seemed and yet in the flower of manhood; and wisdom sat upon his brow, and strength and healing were in his hands, and a light was about him."[115] Then the people praise him. Faramir cries out, "Behold the King!" The trumpets begin to blow. There is music and more singing as the king passes "through the

[111]Jonathan Witt and Jay Richards, *The Hobbit Party: The Vision of Freedom That Tolkien Got, and the West Forgot* (San Francisco: Ignatius, 2014), 145.

[112]*RK*, 947.

[113]*RK*, 944.

[114]*RK*, 946.

[115]*RK*, 947.

flower-laden streets."[116] Thus begins the reign of Aragorn son of Arathorn—the king in all his glory.

Tolkien's description of Aragorn's enthronement calls to mind many points of comparison to the second coming of Jesus Christ—his coronation and his exaltation. The Bible promises a king who will come wearing a white robe (Dan 7:9) and a golden crown (Rev 14:14), who will be called "the Ancient of Days" (Dan 7:9, 13, 22), who will shine with an effulgence of light (Rev 21:23), who will enter the eternal city (Rev 21–22) to sit exalted on his everlasting throne (Ps 45:6-7; Is 6:1; 52:13; Rev 4; 7:9-12). Tolkien's imagination clearly was inspired by the kingdom promises that he read in the Bible, and his royal vision, in turn, inspires our own hope in a coming kingdom.

Tolkien even gives us a glimpse of a glorious resurrection—not a risen king, perhaps, but at least a glorified one. Unlike Arwen, Aragorn is not immortal. "I shall die," he acknowledges to Gandalf. "For I am a mortal man, and though being what I am and of the race of the West unmingled, I shall have life far longer than other men, yet that is but a little while; and when those who are now in the wombs of women are born and have grown old, I too shall grow old."[117] So it was that after many golden years—this story is not told in *The Lord of the Rings* proper, but in an appendix called "Follows a Part of the Tale of Aragorn and Arwen"—the king went to "the House of the Kings in the Silent Street" and "laid him down on the long bed that had been prepared for him." He did not lay down his life in despair, like some pagan king, but in the hope that one day the world would be changed. "Behold!" he said to his beloved bride. "We are not bound forever to the circles of the world, and beyond them is more than memory. Farewell!"

[116]*RK*, 947.
[117]*RK*, 950.

Arwen wept to see his passing. "Estel, Estel!" she cried as her beloved gently fell asleep. "Then a great beauty was revealed in him," Tolkien writes, "so that all who after came there looked on him in wonder; for they saw that the grace of his youth, and the valour of his manhood, and the wisdom and majesty of his age were blended together. And long there he lay, an image of the splendor of the Kings of Men in glory undimmed before the breaking of the world."[118]

Even if there is no literal, bodily resurrection in *The Lord of the Rings*, Gandalf, Frodo, and Aragorn each pass through death in one way or another and then return to life. They are all changed, or else are revealed in some new degree of glory. Like the true Messiah, they are "crowned with glory and honor because of the suffering of death" (Heb 2:9). When the wizard is dragged down to hell by the Balrog, he returns as Gandalf the White. When Frodo receives a mortal wound from Shelob, Sam sees him shining like a beautiful star in a dark cavern. When Aragorn lies down to die, his splendor remains undimmed. Apparently, Tolkien could not conceive Middle-earth without giving us images of the Messiah. And as these three messianic figures came to life—as the character of Christ came through in his prophetic, priestly, and kingly dimensions—inevitably their creator was compelled to give us intimations of immortality. Indeed, Tolkien confided in one of his letters, "I do not think that even Power and Domination is the real center of my story. . . . The real theme for me is about something much more permanent and difficult: Death and Immortality."[119]

[118]Tolkien, "Aragorn and Arwen," in *RK*, 1037-38.
[119]Tolkien, *Letters*, 246 (no. 186). In another letter he wrote, "Longevity or counterfeit 'immortality'... is the chief bait of Sauron—it leads the small to a Gollum, and the great to a Ringwraith." *Letters*, 286 (no. 212).

Death could never have the last word in Middle-earth, only life. In his essay "On Fairy-Stories," Tolkien confessed his undying faith in "the Consolation of the Happy Ending." The author saw this as one of the most important commonalities in literature. The Gospels themselves resemble fairy stories in their climactic and exultant joy. *The Lord of the Rings* follows this literary pattern exactly. Tolkien invented a word to describe it. He called it *eucatastrophe*, by which he meant "the good catastrophe, the sudden joyous 'turn.'" Just when everything seems to be lost—at the Gates of Mordor, for example, or most of all on the cross of Calvary—defeat suddenly turns to victory, leading to unimaginable joy. This "sudden and miraculous grace," as Tolkien called it, "does not deny the existence of *dyscatastrophe*, of sorrow and failure: the possibility of these is necessary to the joy of deliverance; it denies (in the face of much evidence, if you will) universal final defeat and in so far is *evangelium*, giving a fleeting glimpse of Joy, Joy beyond the walls of the world, poignant as grief."[120]

The greatest conceivable eucatastrophe, of course, is the gospel itself, which begins and ends in absolute joy. Tolkien thus described the birth of Jesus as "the eucatastrophe of Man's history" and his resurrection as "the eucatastrophe of the story of the Incarnation." In effect, the gospel is the fairy story that has become history. But it does not for this reason make fairy stories unnecessary. On the contrary, the gospel sanctifies fantasy. "The Evangelium has not abrogated legends," Tolkien writes; "it has hallowed them, especially the 'happy ending.'"[121] Fairy stories have the capacity, therefore, to enrich our experience of creation and redemption.

Does any author do this better than J. R. R. Tolkien? His description of the emotional impact that eucatastrophe has on us

[120]Tolkien, "On Fairy-Stories," 68-69.
[121]Ibid., 72-73.

captures perfectly the experience that many readers have with *The Lord of the Rings*. When defeat turns to victory, "we get a piercing glimpse of joy, and heart's desire," and the joy of our desiring comes with "a catch of the breath, a beat and lifting of the heart, near to (or indeed accompanied by) tears."[122]

LEADING LIKE A KING

The center of all joy is Jesus Christ—the word-speaking prophet, the sacrifice-offering priest, and the peace-bringing king. For those who live in the joyful expectation of his return, the offices of Christ set the pattern for our present service to his kingdom. Thus far we have considered our ministry as prophets and as a community of priests. What can be said about our calling as kings and queens?

My own context for asking this question is in serving as the president of a Christ-centered college. To see a kingly dimension to campus leadership is not to advocate for an imperial presidency. Rather, it is to recognize that as the sovereign Christ fulfills his kingly office, he appoints certain leaders to serve particular institutions, and the proper exercise of their God-given authority brings blessing into the world.

College presidents partly fulfill their kingly office through their public leadership on ceremonial occasions. There must be more than symbol and style, however; there must be substance. Presidents fulfill their royal office by organizing their campuses for success, by providing wise guidance for their governing boards, by hiring and developing a team of gifted leaders, and by implementing an expansive vision. Building and maintaining facilities is a kingly function. So are supporting academic programs and expanding

[122]Ibid., 69-70.

intellectual influence through centers and institutes that build the church and benefit society. Strong kings and queens are defenders. So the calling of kingship includes protecting an academic institution from internal and external threats to its missional identity, theological integrity, financial health, or legal standing.

When presidential leadership is carried out wisely, graciously, and effectively, it brings *shalom* to a campus community. There are also dangers, however. Power and privilege do not promote virtue. James Davison Hunter sees a paradox at work here: "The paradox is that all Christians are called to a life of humility, of placing others' interests ahead of their own, of attending to the needs of 'the least among us.' Yet leadership inevitably puts all in relative positions of influence and advantage."[123] Therefore, college presidents do well to remember the pattern of Christ's kingship, in which the leader becomes the servant and power is exercised for the weak. Jesus Christ is the living proof of his own principle that "whoever would be great among you must be your servant, and whoever would be first among you must be slave of all" (Mk 10:43-45; cf. Jn 13:1-17). Christian leaders should never forget that they serve a king who died for his kingdom.

It would be a mistake, however, to think that the only way to avoid the royal temptations of a college presidency is simply to abandon its prerogatives. As Andy Crouch has demonstrated, power and privilege are divine gifts—dangerous gifts, perhaps, but gifts nonetheless.[124] Thus it is not the right and proper use of privilege that dishonors God, but its abuse or misuse. Thankfully, there

[123]James Davison Hunter, *To Change the World: The Irony, Tragedy, and Possibility of Christianity in the Late Modern World* (Oxford: Oxford University Press, 2010), 259.

[124]Andy Crouch, *Playing God: Redeeming the Gift of Power* (Downers Grove, IL: InterVarsity Press, 2013).

is a reasonable criterion to help us know the difference: Am I taking advantage of this privilege primarily for my own benefit—in which case my presidency is more pomp than circumstance—or am I using it to benefit others and ultimately to bring honor and glory to God? On the rare occasions when Jesus claimed the right to use something—for example, the upper room where he washed the feet of his disciples (Jn 13:1-20; cf. Mt 26:17-18)—he used what he claimed in service to others. Our Savior's example leads Crouch to conclude, "Love transfigures power. Absolute love transfigures absolute power. And power transfigured by love is the power that made and saves the world."[125]

CHRIST IN ALL HIS OFFICES

It could equally be said that power transfigured by love is the power that saves Middle-earth—not just the power of Aragorn's love but his love conjoined with Gandalf's wisdom and Frodo's perseverance through his friendship with Sam. The salvation of the kingdom requires nothing less than the unified efforts of all three Christ figures—the messiahs of Middle-earth. Their enemy's strategy is to divide them.[126] But the convergence of prophethood, priesthood, and kingship proves sufficient to tear down the walls of Mordor, to defeat the dark forces of evil, and to establish a golden kingdom.

To some extent, we see the three offices converge within each of these characters. The prophet Gandalf is said to have "a power beyond the strength of kings."[127] At the end of the novel he performs the priestly roles of crowning the king and pronouncing a blessing on him: "Now come the days of the King, and may they

[125]Ibid., 45.
[126]See FR, 339; RK, 833.
[127]TT, 489.

be blessed while the thrones of the Valar endure!"[128] Similarly, when Aragorn comes into his own, he fulfills the medieval ideal of "sacral kingship," in which the king is also a priest as the royal and the sacred become one.[129] According to Tolkien, this had always been the ideal in Númenor: priesthood and kingship so closely identified that worship of the true God could only be restored when the rightful king was on the throne.[130] Even Frodo takes on an almost kingly demeanor at Mount Doom when Sam falls on his knees and calls him "Master!"[131]

In less dramatic fashion, the convergence of Christ's offices should be one of the goals of Christian leadership. Anyone who has a sacred calling to lead should desire to see all three offices become more fully integrated in one person, and thus to become more Christlike. Richard Mouw characterizes the three dimensions of Christian leadership as follows:

> The ability to discern the status quo empathetically, identifying—even identifying *with*—the actual concerns, desires, fears, hopes of one's followers: this is the priestly. The capacity for shaping and articulating a vision for the goals to which followers must be led: this is the prophetic. The ability to effectively facilitate movement from one to the other: this is the ruling function.[132]

Teaching and communicating, mediating and interceding, ruling and governing—in the person and work of Jesus Christ, all three offices are fully and perfectly integrated. Indeed, this is why

[128] *RK*, 946.

[129] Ford and Reid, "Councils and Kings," 72. See also Scarf, *Ideal of Kingship*, 155-57.

[130] Tolkien, *Letters*, 206-7 (no. 156).

[131] *RK*, 926.

[132] Richard Mouw, "Leadership and the Three-Fold Office of Christ," in *Traditions in Leadership: How Faith Traditions Shape the Way We Lead*, ed. Eric O. Jacobsen (Pasadena, CA: The De Pree Leadership Center, 2006), 127.

theologians typically have expressed the *munus triplex* in the singular, as the "threefold office" rather than the "three offices" of Christ. The promised Messiah does more than execute each office flawlessly; as one whole person he carries out all of their functions harmoniously, fulfilling each office with the virtues of the others. His wise teaching comes with royal authority, his kingly rule is exercised with priestly sympathy, and so on.[133]

What we find in practice, unfortunately, is that most leaders are gifted in one or two offices but somewhat deficient in at least one of the others. Richard Mouw diagnoses the problem:

> If the three functions are not integrated, the result will be an imbalance of one of three types. A priestly imbalance is an empathy that has no clear sense of where to go and no ability to move. . . . A prophetic imbalance is a vision of the way things could be, without a grasp of present realities and an inability to facilitate healthy change. A rulerly imbalance is a skill in making things happen without either an empathetic grasp of the present or a vision of a future that is good for the followers.[134]

The negative consequences of such imbalances are easy to multiply. Without a strong prophetic gift, institutions drift from their mission, which in the case of Christian institutions almost always means spiritual and doctrinal declension. Without a strong priestly gift, a community becomes more legalistic and less genuinely pious. Without a strong kingly gift, things are not well run and problems tend to fester.

[133]See W. A. Visser 't Hooft, *The Kingship of Christ: An Interpretation of Recent European Theology; The Stone Lectures for 1947 Delivered at Princeton Theological Seminary* (New York: Harper, 1948), 16-18, 130-31.

[134]Mouw, "Leadership," 119.

The challenge, of course, is that Christian communities everywhere need leadership in all three dimensions. They need vision and instruction that are consistent with the Word of God (prophetic office). They need a ministry of presence and prayerful dependence on God's grace (priestly office). They need clear doctrinal boundaries, wise allocation of resources, and decisive leadership on strategic priorities (kingly office). Thus, every Christian leader should aim to integrate all three offices. However imperfectly, the best and most complete leaders embody the ministry of Christ in multiple dimensions.

Of course, no one lives up to the high biblical standard of the threefold office of Christ. As Richard Mouw rightly acknowledges, we cannot "hope to display the kind of three-office integration that we see revealed in the person of Jesus."[135] To one degree or another, we are all false prophets, flawed priests, and failed kings. Our prophetic falsehoods, priestly impurities, and royal failures reveal the profound need that all of us have for the ministrations of the Messiah in all his offices. We are utterly dependent on Christ the prophet, Christ the priest, and Christ the king. Here is how the Dutch theologian Herman Bavinck summarizes our circumstance: "We need a prophet who proclaims God to us, a priest who reconciles us with God, and a king who in the name of God rules and protects us."[136]

Another way to say this is that we all need the gospel. This point takes on particular force when we recognize how Christ's offices converge at the cross. In his crucifixion, our Savior simultaneously fulfilled all three of his offices.[137] He carried out his

[135]Ibid., 128-29.

[136]Herman Bavinck, *Our Reasonable Faith: A Survey of Christian Doctrine*, trans. Henry Zylstra (Grand Rapids: Baker, 1956), 335.

[137]See J. C. Ryle, *Luke, Expository Thoughts on the Gospels* (Carlisle, PA: Banner of Truth, 2012), 345. On the connection between Christ's kingship and the cross, see Jeremy R.

priestly ministry in the very act of making an atoning blood sacrifice and also in the prayer he offered for his enemies (Lk 23:34). In his dying hours, Jesus exercised his prophetic office by demonstrating the fulfillment of many prophecies in the manner of his death and by teaching onlookers the Word of God (e.g., Lk 23:46; cf. Ps 31:5).

John Calvin added a third office by defining the crucifixion as a royal act in which the king was lifted up to unexpected triumph: "There is no tribunal so magnificent, no throne so stately, no show of triumph so distinguished, no chariot so elevated, as is the gibbet on which Christ has subdued death and the devil."[138] In viewing the cross from the perspective of the crown, Calvin was seeing things in biblical perspective. The passion narrative in the Gospel of Mark makes repeated reference to Christ's kingship (e.g., Mk 15:2, 18, 26, 32). Jesus himself had promised that when he was "lifted up from the earth," he would "draw all people" to himself (Jn 12:32).

Calvin was not the first theologian to see the cross as a kind of throne. "The Lord has established his sovereignty from a tree," said Augustine in his *Exposition of Psalm 95*. "Who is it who fights with wood? Christ. From his cross, he has conquered kings."[139] Nor was Calvin the last to make this connection. In his commentary on the Gospel of Mark, Joel Marcus writes, "Ensconced on the royal seat of the cross, the crucified person was a king of fools; but the supreme irony for Mark is that in the present instance this laughing-

Treat, *The Crucified King: Atonement and Kingdom in Biblical and Systematic Theology* (Grand Rapids: Zondervan, 2014), especially the discussion of the threefold office of Christ on 165-73.

[138]John Calvin, *Commentary on Philippians-Colossians* (Grand Rapids: Baker, 1979), 191.

[139]Augustine, quoted in Treat, *Crucified King*, 29. See also Karl Barth, *Church Dogmatics* IV/2, ed. G. W. Bromiley and T. F. Torrance (Edinburgh: T&T Clark, 1958), 291, who says it was "supremely in His cross" that Christ "acted as the Lord and King of all men" and "maintained and exercised His sovereignty."

stock of a 'king' is indeed being installed as the monarch of the universe. Having been clothed, crowned, and hailed as a king in the previous section, Jesus is now royally enthroned—on a cross."[140]

This death was not the end, of course, but only the beginning. Christ is risen, and thus he continues to exercise his threefold office though the Holy Spirit. According to T. F. Torrance, "when the New Testament speaks of Jesus being raised up, it evidently refers not only to the resurrection of his body from the grave but to his being raised up as the messiah, the anointed prophet, priest, and king."[141] As soon as he was raised from the dead, Jesus resumed preaching the kingdom of God, teaching his disciples the implications of the cross and the empty tomb—a prophetic ministry of the gospel (see Lk 24:44-49; Acts 1:1-3). Forty days later, his ascension served as a coronation. The royal Son returned to his Father's glory, where he was crowned with kingship and enthroned with everlasting honor (1 Tim 6:15; Heb 2:7-9). All things were placed under his dominion in anticipation of his universal rule at the final judgment (1 Cor 15:27). But the exaltation of the Christ has a priestly as well as a kingly dimension. Having presented his sacrifice in the heavenly holy of holies, our great high priest is now "seated at the right hand of the throne of the Majesty in heaven" (Heb 8:1; cf. Rom 8:34), where he exercises a permanent priesthood. In short, "the historic offices of Christ and our participation in them are not forgotten but eternally transfigured."[142] This is all

[140]Joel Marcus, *Mark 8–16*, Anchor Yale Bible Commentary (New Haven, CT: Yale University Press, 2002), 1049-50.

[141]Thomas F. Torrance, *Atonement: The Person and Work of Christ*, ed. Robert T. Walker (Downers Grove, IL: IVP Academic, 2009), 206.

[142]Geoffrey Wainwright, *For Our Salvation: Two Approaches to the Work of Christ* (Grand Rapids: Eerdmans, 1997), 185. Dane Ortlund explores the implications of Christ's resurrection and ascension for all three offices in "Resurrected as Messiah: The Risen Christ as Prophet, Priest, and King," *Journal of the Evangelical Theological Society* 54, no. 4 (December 2011): 749-66.

made possible by the gospel: Christ's crucifixion for our sins, together with his resurrection from the dead and ascension to glory.

Every leader—and indeed, every Christian—needs the present ministry of the crucified, risen, and exalted Christ in all his offices. We need a true and final prophet to give us a daily word from God that shapes our vision. We need a great high priest to calm our fears, hear our prayers, and perpetually intercede on behalf of all our limitations. We need a king of kings to defend us from every danger, provide for every need, and guide every decision.

In Middle-earth, the messianic figures that perform analogous functions and meet similar needs bear the names Gandalf, Frodo, and Aragorn son of Arathorn. But when we name the Savior of our world, we call him Jesus Christ, the Son of God.

Response

WILLIAM STRUTHERS

In his analysis of the threefold office of Christ in *The Lord of the Rings*, Dr. Ryken provides a thorough review of different characters—Gandalf, Frodo and Sam, and Aragorn—and how they relate to the offices of prophet, priest, and king. As the respondent to this last office and the character of Aragorn, I find the office of king the most difficult office to relate to. As an American citizen, the notion of having a king is entirely foreign to me. Having grown up in a democratic republic where we vote and then state electors cast votes within the electoral college, I am unfamiliar with what it would be like to have a king who occupies a throne by right of birth. And even when I visit the United Kingdom or get a chance to chat with my British friends, their notions of royalty and what it is like to be subject to royalty (currently a queen, and their current system is more nuanced than I am giving service to) are something that I struggle to make sense of. But it would seem heretical to think of Jesus as president. Prophet, priest, and president may provide an alliterative advantage, but the notion of Jesus needing or campaigning for my vote seems absurd. Jesus doesn't need me to vote for him, nor is he waiting for my acceptance of his lordship to retain his divine regency. So in spite of my discomfort with the notions of royalty and kingship, I find that my understanding of Christ demands this of me.

So what does a neuroscientist/psychologist have to say about a literary analysis of a fictional character within a theological framework? As a brain researcher, the critical analysis of literature

doesn't fall within my typical area of research and inquiry. This has not, however, stopped many neuroscientists from asking questions typically reserved for philosophers, literary critics, theologians, and sociologists or from using their preferred way of approaching these issues. For example, it is easy to find on any news website examples of "Your Brain on . . ." stories. These media reports often take neuroscience research and translate it into layperson's terms to describe how the brain processes information, experiences a stimulus, or generates psychological phenomenon. Neuroscientists and their research have begun to occupy a space in the cultural arena that gives them a particular authority when speaking on many matters. This can be inherently problematic.

In some ways neuroscientists can act as prophets, providing warnings about the direction technology is taking us. Neuroscientists can act as priests. For example, consider the priestly role they fulfill by offering a form of absolution and reducing guilt when they provide an explanation for why the addict is unable to control their addiction, or why someone commits a crime due to a tumor or other brain abnormality. Brain scientists provide a story about our embodied nature and give us a framework for understanding why we feel what we feel and where our longings come from, a way to make sense of the world. Unfortunately, at other times this narrative is poorly developed or woefully misses the mark.

When I was invited to give this response, I contacted a colleague in our biology laboratory, Dr. Nate Thom, a fellow brain scientist who has access to a brain imaging device: an Electroencephalography (EEG) system. On short notice, he allowed me to stop by and (with the aid of one of his research assistants) set me up so that my brain could be measured and my EEG patterns could be analyzed first while I was reading the section in *The Return of the King*

where Aragorn is crowned King of Gondor and then while watching Peter Jackson's movie adaptation of this scene near the end of the film. I spent the better part of a half hour reading from *The Lord of the Rings* over and over and over for five minutes, and my baseline EEG was recorded. After completing the recording of my brain activity, Dr. Thom sent me a lovely series of images from both my reading and my viewing of Aragorn's coronation. They are fascinating heat maps of cortical activity, and they can be dazzling to those who have no experience with this kind of data. They were a spectacular representation of the activity of what was happening in my brain while I was reading or viewing a critical part in the story of Aragorn. This can be helpful in how we understand the different brain regions involved in cognitive processes.

As a psychologist and brain scientist, I am very interested in what is going on neurologically when we are reading or viewing a work of art. I could make sense of the blue regions of my EEG as regions involved in movement and physical sensations of touch (relatively quiet when reading or watching a movie), when compared to the areas that are much more involved in language processing shown by the activated red regions in the temporal lobe when reading. There are also activated, red regions in the visual system, the occipital lobes, when viewing Arwen in the scene at the end of *The Return of the King* movie when she is revealed from behind the banner and comes forward to kiss her beloved Aragorn. These interpretations, however, have a limited level of explanatory power and require a high level of speculation or (at a minimum) correlation with first-person reports. The complexity of my psychological experience and my ability to describe it using sources other than colored brain maps provide a more interesting narrative. My EEG map could easily have been produced as I read about C. S. Lewis's Aslan, J. K. Rowling's Harry Potter, or Charles

Dickens's Oliver Twist. It could also have been produced by comparing the reading a textbook that we use in our neuroscience course with watching an animation of neuron action potentials, or reading a set of IKEA instructions with watching a YouTube video on how to set up my new bookcase. In short, while fascinating and attractive, my brain patterns tell me precious little of importance about Aragorn.

As a neuroscientist, I would say that EEG recordings and reading Tolkien don't inherently correlate. But I do think there is something to be said if we change our frame of reference. If we think of the arc of Aragorn from his introduction in *The Fellowship of the Ring* through *The Two Towers* and culminating in *The Return of the King*, his character development is extraordinary. He is a protector, guide, healer, tracker/hunter, and storyteller. Aragorn protects the hobbits in Bree from the Nazgûl, and he guides them in the safest paths to tread to get them from Bree to Rivendell. Aragorn sees Merry and Pippin's fallen brooches of the leaves of Lothlórien when he is tracking them with Gimli and Legolas across Rohan. With his use of *athelas*/kingsfoil, he is a medic to Frodo after he is stabbed by the Morgul blade on Weathertop and to those who have been touched by the shadow in the Houses of Healing of Gondor after the Battle of the Pelennor Fields.

If I am honest, because of my frailty as a human being, I identify more with Denethor than with Aragorn. In my human nature, I am not the king—I am closer to a steward. The king who I claim, Jesus, appears to have been gone for nearly two thousand years, and I'm happy to be in control of my own little empire, my own little kingdom, and I do not want to give it up. That kingdom is my own heart. In that regard, there is another ruler who I can identify with: Théoden of Rohan. Here is a king who has been lied to, has been poisoned by the spells of Saruman, and is crippled to do anything.

But when the spell is lifted, we see the transformation of Théoden. The strength of his youth is returned. He rides out with Aragorn and saves his people. He then rides on to aid Gondor, and while he dies on the battlefield, he does so not to defend his own home but to defend the homes of those that he is allied with. His allegiance is as much to Aragorn as it is to the ancient alliances. I may not have ridden out in battle, but I identify with the kind of transformation that Théoden experiences.

I see Aragorn primarily through the eyes and foolishness of Peregrin Took. I experience this on a daily basis: my own stupidity, inability, and unwillingness to see the king right in front of me. Too often, like Peregrin, I am picked up and carried away by the enemy, but the king pursues me nonetheless. Once returned to his friends, Pippin becomes a guard of the citadel, the Thain of the Westmarch. It is the love and pursuit of the king that helps Pippin, a foolish Took, occupy an ennobled position.

But the most compelling attribute of Aragorn as king is found in the shared love of Aragorn that allows Gimli and Legolas to set aside generations of enmity between their peoples. Likewise, it is their love of Aragorn that causes them to chase after Merry and Pippin as the three hunters. Through this journey and shared submission to follow Aragorn, the bonds of friendship and love are deepened. These are two unlikely friends. If we go back to the Council of Elrond, we see evidence that these two races do not suffer one another easily. There is a history of mutual distrust and dislike. Glóin's time in Thranduil's dungeon provides an example of how the enmity between fathers can be passed on to their sons. But it is Gimli and Legolas's shared love and submission to the mission of Aragorn that causes these barriers to fall. It is a love that is so deep that, after Aragorn has passed, Legolas builds the ship that carries him and Gimli across the sea to the West. Gimli is

allowed passage because of what he has done for Frodo, what he has done as part of the Fellowship with Gandalf, and the advocacy of Legolas. The Undying Lands do not refuse the bonds of affection between these two former enemies, which is enabled by Aragorn, son of Arathorn, the king of Gondor.

Dr. Ryken has shown how we can look to the example of Aragorn going into the cold dark earth, walking the Paths of the Dead, and coming out the other side. Aragorn's kingship rebuilds Middle-earth, but Aragorn also gives others cause to love across generations of enmity, building fellowship. Legolas and Gimli's shared affection for each other is an echo of Christ's admonition to his disciples that they be known for their love for one another (Jn 13:34-35), and this is possible only because of the king. We may be at war with one another—within our families, as races, as nations—but when we love Jesus, who is our rightful king, our love for one another has no option but to deepen.

AUTHOR INDEX

Subject Index

Scripture Index

The Marion E. Wade Center

Founded in 1965, the Marion E. Wade Center of Wheaton College, Illinois, houses a major research collection of writings and related materials by and about seven British authors: Owen Barfield, G. K. Chesterton, C. S. Lewis, George MacDonald, Dorothy L. Sayers, J. R. R. Tolkien, and Charles Williams. The Wade Center collects, preserves, and makes these resources available to researchers and visitors through its reading room, museum displays, educational programming, and publications. All of these endeavors are a tribute to the importance of the literary, historical, and Christian heritage of these writers. Together, these seven authors form a school of thought, as they valued and promoted the life of the mind and the imagination. Through service to those who use its resources and by making known the words of its seven authors, the Wade Center strives to continue their legacy.

THE HANSEN LECTURESHIP SERIES

The Ken and Jean Hansen Lectureship is an annual lecture series named in honor of former Wheaton College trustee Ken Hansen and his wife, Jean, and endowed in their memory by Walter and Darlene Hansen. The series features three lectures per academic year by a Wheaton College faculty member on one or more of the Wade Center authors with responses by fellow faculty members.

Kenneth and Jean (née Hermann) Hansen are remembered for their welcoming home, deep appreciation for the imagination and the writings of the Wade authors, a commitment to serving others, and their strong Christian faith. After graduation from Wheaton College, Ken began working with Marion Wade in his residential cleaning business (later renamed ServiceMaster) in 1947. After Marion's death in 1973, Ken Hansen was instrumental in establishing the Marion E. Wade Collection at Wheaton College in honor of his friend and business colleague.

Finding the Textbook You Need

The IVP Academic Textbook Selector
is an online tool for instantly finding the IVP books
suitable for over 250 courses across 24 disciplines.

ivpacademic.com